ALISON AMBROSE

Discovering
English
Watercolours

SHIRE PUBLICATIONS LTD

Contents

British Library Cataloguing in Publication Data available.

The cover illustration is a detail from 'The Rabbit Hutch' (1861), a watercolour by Walter Goodall (1830-99); private collection.

In memory of Susan Gowing.

Copyright © 1987 by Alison Ambrose. First published 1987. Number 276 in the Discovering series. ISBN 0 85263 902 3.
All rights reserved. No part of this publication may be reproduced or transmitted in any form or by any means, electronic or mechanical, including photocopy, recording, or any information storage and retrieval system, without permission in writing from the publishers, Shire Publications Ltd, Cromwell House, Church Street, Princes Risborough, Aylesbury, Bucks HP17 9AJ, UK.

Set in 9 point Times roman and printed in Great Britain by C. I. Thomas & Sons (Haverfordwest) Ltd, Press Buildings, Merlins Bridge, Haverfordwest, Dyfed.

1. Watercolour technique

Watercolour is a combination of pigment and a binding material such as gum arabic which is then applied to paper with a brush full of water. The binding material is necessary for the pigment to adhere to the paper and today watercolour is usually bought in the form of cakes or tubes where pigment and glue are already mixed. Watercolour is a transparent medium and one wash of colour is visible beneath another and light from the white paper is usually reflected as the layers of pigment placed on the surface are normally thin.

Bright pure colour and luminous effects give watercolour a freshness and directness which are particularly suitable for expressing the changing nuances of the weather and the atmosphere as well as effectively conveying the fresh, bright colours of flowers. The medium is ideal for these subjects as it is quick-drying and transparent so that the artist can work swiftly with the minimum of tools to capture fleeting effects, in complete contrast to oil, which takes days, sometimes years, to dry and is an opaque rather than a transparent medium. However, because watercolour is both transparent and quick-drying it demands a great deal of skill from the artist as, unlike with oil, mistakes cannot be easily covered up.

Many watercolourists work in gouache or bodycolour. This technique involves mixing the watercolour with Chinese white or other white paint which thus makes the paint opaque. Many painters used gouache in the eighteenth and early nineteenth centuries because it was not unlike oil paint in appearance and oil was then considered a superior medium to watercolour.

Towards the end of the eighteenth century the watercolour artist usually prepared his own colours by grinding them from natural products such as roots, minerals or animal substances. Then he would mix the pigments with gum arabic, thus making them up into cakes. The firm of Reeves became the first to make up colour commercially into small hard cakes in about 1780. However, there were disadvantages as the cakes often dried or crumbled with age or deteriorated in a hot climate. Usually the artist dipped the cake in water and rubbed it into small china saucers of between 2½ and 3 inches (65 and 75 mm) in diameter. Early miniature artists used oyster shells for this purpose and until the eighteenth century oyster shells were still used for preparing washes for the sky.

The next development came when colours were put into small white pans which fitted into containers of a standard size in a paintbox. The colour was often moister as it contained some honey or glycerine. In 1846 Windsor and Newton began to put moist colours into metal tubes. However, many artists today

prefer the pans of colour as they are purer than the colours in tubes, which have to be mixed with a fair amount of honey or glycerine so that they can be easily squeezed out.

In the eighteenth century most watercolour artists worked by adding colour to a drawing which had been made with either pencil, charcoal, chalk or pen and ink. The colour most often used was blue, with some artists, like J. R. Cozens, using a hint of pink. Vibrant colours were not much used until the nineteenth century. In 1746, when travelling in Italy, Alexander Cozens always carried lampblack and gum for making ink. In 1797 Sandby wrote to the Reverend W. Mason about a great discovery he had made: 'A few weeks ago I had a French brick (brioche) for breakfast; the crust was much burnt in the baking, I scraped off the black and ground it with gum and water. It produced an excellent warm black colour.' A browner ink can be made with bistre. Bistre is made from the soot of burning wood, resin or peat. As an ink it is hardly distinguishable from sepia, which is obtained from the cuttlefish.

Almost all the earlier watercolour painters used pen and ink outlines as the foundation of their 'stained' or tinted drawings and the use of ink either for this purpose or as a reinforcement to finished work in colour has continued to the present day. Turner frequently added touches to his later drawings with a pen and ink. Ink can be applied with a brush as it was by Alexander Cozens in his 'blot' drawings. Chinese and Japanese artists used a brush for all their drawings and calligraphic writings. In early times when a pen was used it was a quill. Then the reed pen was introduced in the eighteenth century and used by artists such as Rowlandson with great expression. Today steel nibs of all kinds and widths are used although some artists still prefer a quill or reed pen, whilst others use a brush. Even today most watercolour artists use a preliminary drawing and highlight particular features in ink, and a pure watercolour is difficult to find.

Watercolours today may be painted either on machine-made paper or on hand-made. The manufacture of hand-made paper was introduced into England by a German, Sir John Spielman, in 1588. Machine-made paper such as cartridge paper was not produced in Britain until the beginning of the nineteenth century, when the Fourdrinier papermaking machine was first imported. Handmade paper is far superior in quality and durability to machine-made paper and small quantities are still produced. Mr Barcham Green of the Hayle Mill, Maidstone, said of the difference between hand-made and machine-made paper: 'It may be compared to the difference between an original watercolour drawing and a cleverly printed reproduction. It cannot be easily explained but the artist can tell at a glance which is which.'

The ingredients used for hand-made paper are white linen and cotton rags which are carefully sorted so as to get rid of any extraneous matter. Then they are broken down by repeated washing, boiling and rubbing until they become a pulp. The pulp is bleached and cleansed with pure spring water until it is free of all starch, dirt and grease. Genuine hand-made paper is manufactured by a vatman who handles a mould, a wooden frame containing a woven wire cloth in which the design of the watermark is embodied. The vatman passes the mould to the coucher, who presses the mould on to a pile of blankets or felts. A film of paper adheres to the felt and then the coucher passes back the clean mould to the vatman to make another sheet. The pile of felts with sheets of paper between is then transferred to a hydraulic press and the excess water from the sheets is pressed out. It is during the process of pressing that the familiar and characteristic grain in the surface of hand-made paper is obtained.

The newly made sheets (known as waterleaf) must be treated with size. This is done by passing them through a trough of animal or gelatine size; the excess size is squeezed out by rollers. Sized paper dries in about 48 hours and is then stored in a cool place until it is ready for use.

Every painter had his favourite type of paper. Some liked a thick and highly sized paper whilst others preferred a thin paper; some favoured a smooth surface, some a rough surface. The papers used throughout the seventeenth and eighteenth centuries were hand-made and had a lovely quality of tone but they were unsuitable for many of the techniques developed by watercolour artists in the eighteenth and nineteenth centuries. To meet their needs in the second half of the eighteenth century Whatman was the first to produce a hand-made paper which would stand up to repeated washings and scrubbings. About 1800 the firm of Creswick made papers of various qualities and textures which suited the needs of many artists: for example 'De Wint' was a special kind of Creswick paper which became very popular with painters like David Cox because its texture, absorbency and colour became integral features of their work.

During the nineteenth century papers were made in various tints suitable for use with bodycolour. A painter in pure watercolour might like paper of a cream or ivory tone as he could incorporate this off-white colour in his work. Previously, in the eighteenth century, tinted papers were made by staining white paper with bistre or with water coloured by tobacco leaves, or by boiling brewers' clay in beer and putting it on the paper with a sponge. Other artists dipped their paper in coffee. For instance, in his 'Scottish' group of drawings done in 1801 Turner worked with chalk and pencil heightened with white on a yellowish

brown paper which was stained with a mixture of Indian ink and tobacco juice. Some artists found the paper too absorbent and Sandby primed his paper with isinglass jelly mixed with honey.

Since the Renaissance paper has been made up into sketch-books which can be easily carried around. Leonardo wrote of 'your little book which you should always carry with you', advice which is still given in art schools today. The Victoria and Albert Museum has collections of sketchbooks by Place, Wilson, Constable, de Wint and others and 350 of Turner's sketchbooks have been bequeathed to the nation. In 1832, recognising the need for artists to make sketches, the firm of Windsor and Newton advertised solid sketchbooks in which each sheet of paper could be easily cut out with a knife.

From about the fifteenth century until around 1850 the artist's paintbrush was normally described as a 'pencil'. The first brushes were quill brushes and these gave way to brushes with wooden handles. As they are today, the best brushes were made of sable hair and inferior ones from camel hair. Some artists, such as Samuel Palmer, used brushes which were 2 inches (50 mm) wide.

Colour may be applied by separate touches, flecks or dashes made with a wet brush. Much of David Cox's work was done entirely with separate strokes of the brush almost in the manner of some of the Impressionist artists. Colour may also be applied by stippling or by a wash. Stippling is the use of a fine paintbrush to put individual touches of colour side by side as well as to lift up colour from a wash, thus breaking it up into a very large number of spots. It is a very fine, exacting technique, which became a favourite with artists such as William Henry Hunt, Birket Foster and J. F. Lewis, all of whom used a white ground as a basis to their work. This helped to give the colour a richness and opacity normally associated with oil.

Watercolour artists also used washes a great deal. A wash is an application of colour over a large area perhaps of 2 square inches (13 sq cm) or is used for a sky stretching over a much greater area. Artists mixed up the colour for washes beforehand so that they could then be applied in a fairly broad manner. Washes would often be used over a pencil or pen drawing. This was the most usual practice in the eighteenth century when 'stained' drawings accounted for the majority of watercolours. When a wash had dried, or even when it had not, some artists would lay another wash on top of it. Further effects could be obtained by lifting out colour with a sponge, blotting, scraping or rubbing. All these methods were used by Turner but the paper had to be of sufficient absorbency to withstand them.

As watercolour is essentially a transparent technique a dark colour cannot be covered up with a light colour. Instead, any colour not required was lifted by use of rags, blotting paper, a

rubber, a knife or even bread. In addition to correcting his mistake the artist could also create pleasing textural effects at the same time.

Experiments with different brushes, papers, pens and colours reached their peak in the nineteenth century, when manufacturers produced most of the necessary equipment. All these technical improvements in the eighteenth and nineteenth centuries helped to make it possible for each artist to develop his own style fully by experimenting with the watercolour medium.

Mounts and frames

A mount displays a painting to advantage, covering any ragged edges and improving its appearance because of its contrasting tone or tint. It also protects the drawing from getting dirty if it is in a portfolio or solander box and if it is put into a frame it is kept from coming into contact with the glass.

At the end of the eighteenth century artists put their watercolours into white, cream or greyish mounts with tinted borders round the margin of the drawing. The idea was to link the mount and drawing by using similar tones and tints so that, instead of the mount acting as a window, it and the drawing appeared as a unified flat decoration for a wall. But from the time of the foundation of the Old Watercolour Society in November 1804 it was customary for artists who exhibited with them to present their work in heavy gold frames without any mount. W. H. Pyne wrote of 'watercolours, displayed in gorgeous frames, bearing out in effect against a mass of glittering gold as powerfully as pictures in oil'. The vogue for gold frames and mounts continued through the nineteenth century. It was fostered by the picture dealers who in the prosperous 1880s and 1890s were supplying the *nouveaux riches* of the provinces with Birket Fosters, Coxes and Copley Fieldings in gold frames and mounts, partly to make the buyer feel that he was getting good value for money and partly because the elaborate frames went very well with an ornate Victorian sitting room.

In 1900 the New English Art Club promoted a revival of the watercolour drawings opposed to the Victorian watercolour painting and encouraged the use of a simple frame and plain mount, sometimes with a wash border instead of a gold one, but it was not until 1914 that Terrick Williams led a revolt against gold mounts at the Royal Institute of Painters in Water-Colours and demanded white mounts. So great was the opposition that it was a year before white mounts were permissible and even then they were put on a separate wall; but after 1916 gold and white were gradually mixed and white mounts eventually became more prominent.

At the Royal Society of Painters in Water-Colours it was

customary to insist on gold mounts for the spring exhibitions and white mounts in the winter exhibitions. But, following the Royal Institute, a rule was passed in 1915 that gold mounts should no longer be essential. The Royal Academy never had a rule about gold mounts but nevertheless it was not until 1915 that white and cream mounts were passed by the hanging committee.

Today most watercolours are put in white or cream mounts as it is generally agreed that they do not detract from the delicacy of the colour and tone of watercolour work.

2. The beginnings

Cave paintings, classical wall paintings and frescoes all have affinities with watercolour because they used pure thin pigment which had to be applied quickly as it soon dried. Cave paintings represent the beginning of painting and are historically the oldest use of watercolour. However, cave paintings, classical wall paintings and frescoes were rarely found in England, and therefore cannot be said to be close ancestors of the English watercolour. A closer link may be found between English watercolour and the illuminated manuscript.

Illuminated manuscripts were painted in bodycolour or watercolour on vellum. Vellum is a kind of fine parchment which is stiffer and more absorbent than ordinary paper. Most illuminated manuscripts were executed in bodycolour although some manuscripts belonging to the Earl of Leicester, which include drawings by Matthew Paris, are painted with transparent watercolour and are therefore associated with pure watercolour technique. However, manuscripts were meant for private rather than public contemplation. A striking characteristic of illuminated manuscripts is the wealth of minute detail and other highly decorative features.

Portrait miniatures painted by sixteenth-century artists such as Holbein, Hilliard and Isaac and Peter Oliver also have affinities with watercolour. Indeed, in about 1620 Edward Norgate wrote about 'the use of watercolours for miniature portraits' but as with illuminated manuscripts the watercolour was mixed with white and was therefore the opaque medium of gouache and the paint was applied to vellum, while later miniatures such as Holbein's portrait of Anne of Cleves were painted on ivory. Portrait miniatures, like illuminated manuscripts, were also meant for private rather than public contemplation.

The earliest and one of the most influential artists to use watercolour as a medium to depict landscape was the German **Albrecht Dürer** (1471-1528). In the fifteenth century he travelled across the Alps sketching the mountains and the valleys. He added colours to his drawings and the colour forms an integral part of some of his works. His colour was often laid in thin, transparent washes although he sometimes used bodycolour. Dürer influenced English watercolourists such as Samuel Palmer and as his work was known and revered in England he is an important figure in the history of the English watercolour.

In the sixteenth century the French artist **Jacques le Moyne de Morgues** (died 1588) came to England and depicted in pure watercolour many of the flowers and fruits which were found in English gardens at that time. He mostly used thin washes of colour over the drawings rather than mixing them with white. A

watercolour of a pear and other examples of his work may be seen in the Victoria and Albert Museum, London.

There are links between the work of Jacques le Moyne and that of **John White**, who accompanied Sir Walter Raleigh on an expedition to North America in 1585 in the capacity of draughtsman. It was his duty to record by making drawings the people, plants, animals, birds and natural scenery of the North Carolina coast. The medium he used was watercolour and his work and that of le Moyne may be seen to represent the beginning of the English watercolour tradition.

Inigo Jones (1573-1652), in addition to his work as an architect, designed scenery and costumes for a long series of masques by Ben Jonson and others. The costume designs may be regarded as some of the earliest of English watercolours as they were finished with colour which was laid on with a full brush. The other drawings were made with pen and ink or sepia wash.

Thus at the beginning of the seventeenth century watercolour was only occasionally used as a medium and both in Britain and elsewhere watercolours of landscape were extremely rare. Writing in the seventeenth century, Norgate points out how landscape had been used for 'filling up the empty corners or void places of figures and story'. Both Rubens and Sir Anthony Van Dyck brought some landscapes to England in the seventeenth century and painted some in England, but neither inspired other artists in seventeenth-century England to paint watercolour landscapes.

3. Topographical watercolours

Topography is the careful and realistic representation of a building, place or view without any personal interpretation being made by the artist. The drawings of the early topographers were entered in the Royal Academy catalogues as 'stained' or 'tinted' because of the methods which the artists used. They first made a careful and accurate drawing in pencil, ink or chalk and then they laid thin transparent washes one on top of another. The washes were usually in monochrome blues or greys. Most topographers could skilfully apply perspective and were good at line drawing. This technique enabled watercolours to be easily translated into engravings. Some watercolourists engraved their own work.

The taste for the topographical watercolour was fostered by an increasing love of travel, a growing appreciation of scenery and architecture and by a greatly expanding production of engravings. Throughout the eighteenth century English aristocrats used to tour the continent on the prestigious 'Grand Tour' or, if they were not so rich, 'Le Petit Tour'. They travelled to France, to the Alps and to Italy, particularly to Rome. They would take an artist with them to record the views, as proof that they had been. It gave many watercolourists work, money and the opportunity to study the romantic continental scenery and the work of Poussin and Claude. On their return to England these examples would affect the way in which they viewed English scenery. By the end of the eighteenth century it was not just the rich who were travelling, but the middle classes too.

Meanwhile in Britain more artists became aware of the natural beauty of such areas as North Wales and the Lake District. They also began to study majestic buildings and historical sites such as the English cathedrals and Stonehenge.

Perhaps the main cause of the boom in topographical watercolours in the eighteenth century was the prolific reproduction of engravings, which enabled an artist's work to be obtained cheaply by a large portion of the public. Publishers were quick to realise the financial rewards of topographical drawings and soon sent artists into every part of Britain to make drawings of castles, cathedrals, country estates, mountains, rivers and lakes.

Wenceslaus Hollar (1607-77)

Wenceslaus Hollar was the first painter directly to influence the direction and technique of English topographical watercolours and one of the first to depict pure English landscape. Hollar was born at Prague and worked at Frankfurt, Cologne and Antwerp. He was brought over to England in 1636 by Thomas Howard, Earl of Arundel, one of the first and greatest

of English connoisseurs and patrons of art. Hollar introduced to Britain the method of washing pen drawings with slight tints of colour, a method which had been practised by Dürer in the sixteenth century and was developed still further by the Dutch artists contemporary with Hollar in the seventeenth century. He used a limited range of colours which included blue, yellow, green, pale brown and a rose madder for roofs. Hollar's work, some of which depicts places which Arundel visited, is important because it shows the two main traditions associated with the early English watercolour, the topographical and the romantic. The former was done in a tight linear style while the latter was done in a far looser fashion.

Francis Place (1647-1728)

Hollar influenced the English artist Francis Place, both in style and in choice of subject matter. In his topographical views Place followed Hollar both in method and in using a simple range of colours. He drew with a pen, often using a low viewpoint. Then he used washes of sepia and Indian ink and added little touches of colour. He comes very close to Hollar in drawings such as 'View of the Coast of Lincolnshire' but his work also showed signs of the technique which was usually adopted by the painters of romantic landscape. For instance, in 'The Dropping Well of Knaresborough' his broad handling of light and shade foreshadows the work of Alexander Cozens rather than the work of other topographers.

John Talman (1677-1726)

Another early eighteenth-century topographer was John Talman. The Royal Institute of British Architects owns an album of his which contains many drawings of architecture done in a tightly delineated style which resembles that of Hollar and Place.

Sir James Thornhill (1675-1734)

Another early topographer was Sir James Thornhill, who executed hundreds of drawings in pen and wash and colour, nearly all of which are designs for the decoration of architecture, but two drawings which were presented to the Whitworth Institute, Manchester, in 1935 depict landscape in a bolder way than Hollar and show perhaps that Thornhill had studied Rembrandt. These drawings, one inscribed 'View from ye Toy leads at Hampton Court July 1730, J. TH', the other 'Clermont at a distance. A view of H. Court Ferry from my Lodging Apr. 20, 1731, J. Th.', look forward to the topographical work of Sandby.

William Hogarth and Samuel C. Scott

Other artists who used watercolour in the early eighteenth

century included William Hogarth and Samuel C. Scott. They contributed to the *Five Days Peregrination*, a light-hearted diary of a journey down the Thames with Thornhill. This manuscript record contains some of the few drawings by Hogarth which he washed in colour, as most of his work was in oil.

William Taverner (1703-72)

These early eighteenth-century watercolour artists do not constitute an English tradition of watercolour at that time. The tradition began in the middle to late eighteenth century with artists such as William Taverner and Paul Sandby.

Taverner, like Sandby, preferred to work in watercolour or bodycolour rather than in oil. He produced a fair amount of work in the medium although he was reluctant to show it. His work may be divided into two types, one clearly inspired by the classical compositions of Poussin, such as in his 'Classic Landscape' (Victoria and Albert Museum, 12¾ by 17⅞ inches, 324 by 454 mm) and the other as exemplified in 'Hampstead Heath 1765', where he has responded in his own way to a scene and painted it with great verve and gusto, showing himself to be closer to the romantic spirit than to that of the topographer.

Taverner is important because he was one of the first artists to depict a scene with a personal and emotional response but because he did not exhibit his work, claiming to be an amateur, he is less important a figure than the very public Sandby.

Paul Sandby (1725-1809)

One of the most famous topographers, whose work helped to foster the topographical tradition in England, was Paul Sandby. His compositions are not particularly inspiring but because of his active part in founding the Royal Academy in 1768 and the technical improvements which he made in the watercolour medium, as well as his perfection of the use of aquatint, he not only raised the regard with which watercolour was held in academic circles, but he also earned himself the title of 'Father of the English Watercolour'. He painted almost exclusively in watercolour and rarely in oil. He was one of the earliest artists to appreciate the beauties of Wales and in 1775 published *Twelve Views in Aquatinta from Drawings Taken on the Spot in South Wales.*

Paul Sandby is best known for his numerous drawings and watercolours of Windsor Castle and Windsor Great Park. Stylistically many of these works show the influence of Canaletto. Canaletto visited England in 1746 and painted many pictures of London during his visit. The clarity of Canaletto's technique in delineating buildings and his attention to minute details of ornamentation greatly influenced the eighteenth-

century English topographical painters, including Sandby. Aspects of Canaletto's technique could easily be adapted to depict English buildings and Sandby found that he could use a similar technique to depict Windsor Castle and Park.

Like many other English eighteenth-century topographical artists, Sandby was also influenced by the seventeenth-century French painter Claude, who spent most of his working life in Italy. Claude believed that the essence of the sublime and beautiful in scenery was distilled in classical models and he constructed his paintings in order to attain this ideal. In the foreground trees were usually placed on either side of the picture; a ruin, a bridge or a classical building was usually placed in the middle ground whilst in the background there were mountains or hills which faded into a typical Claudian sunset. The effect was such that it seemed one could walk in the landscape. Sandby adapted this method of composition for many of his drawings and paintings of Windsor.

Sandby worked in both bodycolour and pure watercolour. He often used bodycolour if the work was going to be exhibited because it looked more like oil, which was then the more favoured medium. The other technique which Sandby employed when he did his drawings 'on the spot' was transparent watercolour. Here he showed his innovative ability as he was one of the first watercolourists to use the white of the paper to express either sky, light or air. He also used a reed pen so that his technique was much broader than in his bodycolour work. An example of a work which shows Sandby's broader technique is 'Woodyard, Windsor Great Park'. He also used the reed pen when he was making drawings of trees, although his depiction of trees always made them look stylised rather than living organisms. Nevertheless, his response to Windsor Castle and Windsor Great Park was emotional as is shown by the sheer volume of work which he produced of them. He also responded to the atmosphere of the area: his portrayal of a sunset casting long shadows on the ground is a scene which he recorded repeatedly.

On the whole Sandby used a limited colour range and flashes of bright colour are unknown. He achieved an overall tonal effect by leaving one wash to dry before applying another, so that one colour never blurred into another. His perspective was always accurate and these features, together with his well constructed compositions, lent to his work an overall feeling of order and calm.

Sandby exerted great influence on the subject matter depicted by other English watercolourists. He never went abroad, although he was influenced by artists who had gone on the Grand Tour, such as William Pars, and he made engravings of

Italian scenes done by Pars and others. The style Sandby evolved remained popular for over thirty years.

Thomas Malton senior (1726-1801)

Another important topographer was Thomas Malton. His work concentrated on the architecture of the period. He published a *Complete Treatise on Perspective* in 1775. Malton made about a hundred drawings which he engraved in aquatint for his *Picturesque Tour through London and Westminster* (1792). These drawings show his talents, the precise outlines demonstrating his draughtsmanship while the use of perspective shows him to have been a fine mathematician. The neutral tones and tight delineated style are within the topographical tradition. Both his sons, Thomas Malton junior and James Malton (1766?-1803), developed a similar style.

Thomas Malton junior (1748-1804)

Thomas Malton junior taught perspective to Turner, who was to use Thomas Malton senior's book as a basis for the lectures he gave when he was Professor of Perspective at the Royal Academy. 'South Parade, Bath' and 'The Strand with Somerset House' are good examples of Thomas Malton junior's work which show his ability to use perspective successfully and to portray architecture with accuracy. The works also show the street life of the times, carriages, horse and carts as well as pedestrians, and this makes them interesting historical records which bring Georgian England to life.

Edward Dayes (1763-1804)

The most outstanding of the topographers of the late eighteenth century was Edward Dayes. One of his most famous works is 'Buckingham House, St James's Park' (1790). Here the architecture is of secondary interest and the group of animated figures in the foreground takes precedence. The figures are quite tightly drawn whereas the trees are drawn boldly. Dayes was the author of *An Excursion through Derbyshire and Yorkshire, Instructions for Drawing and Colouring Landscapes* and *Professional Sketches of Modern Artists*. These were collected and published in one volume with the title *The Works of the Late Edward Dayes* after his suicide at the age of forty. Dayes described how he first sketched in the outline with delicacy and precision and then laid on washes with characteristic 'blue' tones, followed by washes of warm colour over the cold blue. The blue effect of his drawings is atmospheric but it does make them seem artificial. Nevertheless Dayes's methods were important, as was his role as a teacher, particularly of Girtin. He also painted pure landscape and towards the end of his life he painted

large classical, historical and religious subjects which came very close in style to William Blake.

Dayes's work marks the transition from the eighteenth to the nineteenth century and his depictions of picturesque ruins such as 'Lympne Castle', are not only typical of the period, with its cult of the picturesque which had been partly fostered by Gilpin's theories, but are also important because of their formative influence on Turner, who copied many of them in his early career.

William Hodges and William Daniell

The Grand Tour was brought to an end in the early nineteenth century by the wars with France. The gentry had had their country seats in England recorded in paint and they also possessed many views of picturesque scenes both in Britain and abroad. Indeed Cozens, Pars, Warwick Smith, Turner and other artists had all painted scenes of France, Germany, Italy and Switzerland and thus made the general public familiar with these places. In the nineteenth century many artists began travelling further afield, to India, Egypt, Greece and to Russia, as most of Great Britain and western Europe had been explored and exploited by watercolour painters.

One of the first to paint the costume, architecture and topography of India was William Hodges (1744-97) and between 1760 and 1820 there were at least sixty British painters who were working in India. Amongst them were Thomas and William Daniell, who went to India in 1786 and as a result of their travels produced *Oriental Scenery*, which was published in six volumes between 1795 and 1808. They used a camera obscura, so that their work was accurately drawn and faithfully represented the scenery they saw.

Between 1814 and 1825 William Daniell produced *A Voyage round Great Britain* in eight volumes. He was a good draughtsman as well as an artist who had a fine sense of design and colour, qualities evident in the views he did of Tenby, Dunbar and Lancaster Castle, which show him to have been an extremely competent topographical artist.

John Frederick Lewis (1805-76)

One of the most imaginative and talented artists to emerge in the early nineteenth century was John Frederick Lewis. Lewis spent a lot of time in the Near East and Holman Hunt saw him as a painter of Egyptian social scenes, of which 'The Harem' is a typical example in terms of both subject matter and technique. Earlier Lewis had travelled to Spain and to Florence and Naples, but in 1840 he set out to the east and went to Athens and to

Constantinople and in November of that year to Egypt. He spent ten years in Cairo. His eastern paintings are amongst his finest work. His technical approach was very close to that of the Pre-Raphaelites, although he did not belong to that group. He began with a white gesso ground and then he would paint in the details with meticulous precision, bringing out every detail of form, texture and colour so that the finished painting seemed like a precious jewel. In 'The Harem' the figures are skilfully grouped and the sunlight is brilliantly rendered and appears to flicker through the shutters and fall on the richly coloured dresses. This picture startled the art world. Ruskin called it 'faultlessly marvellous' and Lewis became famous. In 1851 Lewis returned to London and he was elected President of the Old Watercolour Society in 1855. However, because his elaborately detailed watercolours took so long Lewis later turned to oil paintings, which were quicker to do and so enabled him to make more money. These works were less successful and reflect the insincerity in Lewis's work which divided him from the Pre-Raphaelites. His work is technically brilliant but his paintings are strictly beautiful illustrations rather than great works of art.

William James Müller (1812-45)

Another painter who travelled to the east was William James Müller. In 1838 he went to Greece and then to Egypt, which inspired him greatly. His best work shows an ability to capture the scene by means of the rapid sketch rather than the carefully studied work.

Edward Lear (1812-88)

Edward Lear was another watercolourist who travelled extensively. He went to Rome, Malta, Egypt, Switzerland, Jerusalem, Corfu and Syria, finally settling in San Remo, where he died in 1888. Although chiefly remembered for his nonsense verse and his bird paintings (see chapter 5), he also published in 1851 *Journals of a Landscape Painter in Greece and Albania* and in 1852 *Southern Calabria*. His landscape work shows his ability to depict a wide panorama rather like Peter de Wint although his love of wide open spaces with little detail recalls Francis Towne's work. He usually worked with a pen, using a fine nib for the distance and a reed pen, but sometimes a brush, for the foreground. He used a very simple range of colours. The innumerable notes which he put on his work show that he did not intend to exhibit it. He often camped out in the wild and visited disreputable places in the east and then he would return to London and hold private views of his work in his flat.

Henry Edridge (1769-1821)

Edridge is a link between the earlier topographers and the later school who discovered the picturesque elements of continental scenery and invented new ways of painting them. Edridge was famous for his portraits but he always had a love of landscape. He often used a lead pencil and was very good at drawing architecture, for example his 'Town in Normandy'. Other works such as his cottage and farm scenes are very sensitive and refined and met the changing public taste for more natural scenery.

THE NINETEENTH CENTURY

Between 1821 and 1826 great improvements were made in the art of steel engraving, making it possible for thousands of impressions to be made from a steel plate whereas previously from a copper plate only a few hundred impressions could be made. Annuals could therefore be produced more cheaply and sold at about a guinea. Consequently there was a vast increase in the publication of annuals, including Heath's *Picturesque Annual,* published between 1832 and 1834, the *Landscape Annual,* published between 1830 and 1839, *Gentlemen's Seats and Beauties of Britain,* published in 1839, and *The Continental Annual,* published in 1832 and illustrated by Samuel Prout.

Rudolph Ackermann's publications and the annuals gave great impetus and employment to the topographical artist as they were particularly suited to the style where drawing, skill of perspective and a fine sense of composition predominated. Colour was of secondary importance. The subjects tended to be taken from continental scenery, partly because British scenery had been extensively depicted in the eighteenth century and partly because the middle classes were now travelling abroad and wanted pictures to remind them of their visits. The artists also now tended to concentrate on picturesque buildings and streets rather than more obvious magnificent architecture such as cathedrals and churches.

Artists in this group include Clarkson Stanfield (see chapter 7), James Duffield Harding, William Brockedon, John Gendall, William Nesfield, William Henry Bartlett, Alfred Vickers, William Smallwood and James Holland, but the two most talented were Samuel Prout and William Callow.

Samuel Prout (1783-1852)

Like many of his contemporaries, Samuel Prout travelled abroad and his work was very popular with the British middle classes who were also going abroad in increasing numbers in the nineteenth century and wanted to have mementoes of their

visits. Prout usually depicted a section of a building rather than the whole of it and often he put a group of figures in the foreground, to lead the eye in and give a scale to the work. An example is his picture of the porch of Ratisbon Cathedral. Most of his work is made up from pencil drawings. His paintings of buildings are mainly picturesque views rather than architectural drawings. His colour was restrained and he said: 'Every good artist paints in colour but thinks in light and shade.' He produced eighteen publications, including *A Series of Easy Lessons in Landscape Drawing* (1820). This consists of descriptions of how he painted and influenced amateur artists of the time.

William Callow (1812-1908)

In 1825 William Callow was formally articled to Theodore Fielding, who taught him about watercolour drawing and aquatint engraving. When he was seventeen he was asked by a Swiss artist working in Paris to help him produce engravings for a book on Switzerland. Callow later returned to Paris and with Boys he developed his love of old towns, timbered houses and picturesque street scenes.

At this time, in the 1830s, watercolour drawing was practically unknown in Paris and when he exhibited his 'A View from Richmond' in 1834 at the Paris Salon it brought him immediate success and prestigious pupils such as the seven-year-old Princesse Clementine d'Orléans. His financial security assured, he was able to embark on one of his walking tours, following the Seine to Honfleur. He crossed by steamer to Southampton and then he toured the Isle of Wight, after which he walked from Portsmouth to Winchester. In 1836 he walked 1700 miles (2700 km) through the south of France and in 1838 he toured many parts of Switzerland and Germany on foot. In 1840 he visited Italy, in 1841 Normandy, in 1844 the Rhine and in 1845 Holland. In 1846 he visited Germany, Switzerland and Venice and in 1862 Coburg, Potsdam and Berlin and in 1892 he made a final visit to Italy. On these tours he made hundreds of drawings and copious notes.

In 1838 he was elected a member of the Royal Watercolour Society and in 1841 he left Paris and came to live in London. In 1846 he married Harriet Anne Smart, a niece of Sir George Smart, the Queen's organist, and he soon attracted pupils who paid him well for their tuition.

Stylistically, Callow continued the tradition of the topographer Paul Sandby. He began with a precise drawing and worked over it with slight washes of colour on a non-absorbent paper. There were no alterations, no spongings or scrapings and hardly any use of bodycolour. These qualities may be seen in 'Notre Dame, Paris', which he did in 1835. He always chose a

sunny day and his subject matter included timbered buildings and picturesque street scenes. He never used rain, wind, atmosphere and colour as the romantic landscape artists such as Turner or Cox had done. Instead, like Sandby, he imbued his pictures with a feeling of overall order and calm. However, after his election to the Royal Watercolour Society in 1838 he began to embellish his work with more detail and touches of colour and these paintings did not have the same appeal as his simple earlier works had.

4. Romantic landscapes

The other tradition of watercolours which was developed in the eighteenth century was the romantic tradition. It was fostered by a love of travel and a preference for depicting continental scenery which was both awesome and majestic.

Alexander Cozens, a great originator in English drawing, although he rarely used watercolour, was in Rome in 1746; Richard Wilson was in Rome from 1752 to 1755; Jonathan Skelton reached Rome in 1758; John Robert Cozens was in Rome between 1776 and 1781 and Francis Towne arrived in 1781. The combined effects of the alpine scenery which they had seen on their way, the historical associations of the monuments of Italy, the stimulation provided by other artists and the influence of the works of the classical artists Poussin and Claude are all evident in their work.

All these artists took landscape as their subject but it was landscape which had been romanticised in their own minds. Works such as Skelton's 'Tivoli' and 'Ruins of Paestum' by J. R. Cozens are not depicted as views and architecture in the realistic way that a topographer would depict them but rather the architectural and scenic features were idealised in such a way that they became picturesque works. Towne's watercolours of alpine scenery become almost abstract essays of shape and form.

The romantic artists also preferred to work in a looser style although they still used the same methods and colours as the topographers. For instance in Cozens's 'Ruins of Paestum' the architectural features are not recorded with the precision and accuracy the topographer would have used, but the forms and details are merely suggested. The most important feature of this work is the foreboding atmosphere, which is suggested by the thundery sky and the broad contrasts of light and dark. The desire to record atmosphere rather than just architectural or scenic details marks an important difference between the topographers and the romantics. Alexander Cozens, Jonathan Skelton, Francis Towne and J. R. Cozens may be viewed as the first painters of romantic Italianate landscape. They inspired some of the greatest English watercolourists of the nineteenth century, including Girtin and Turner. They expressed their own personalities in the landscape watercolours which they painted.

Because the romantic or poetic approach to nature is more subjective and the painters were more individualistic in their outlook, the romantics often experimented with the techniques of watercolour in order to record their personal views rapidly. While the topographers followed traditional methods the romantic painters often invented new ones. This imaginative and often inventive approach showed how the watercolour technique could

be used. Ruskin made a distinction between 'simple' and 'Turnerian' topography as being two separate branches of landscape art, the one historical, the other poetical. The poetical approach may be seen in the work of Skelton and Towne and in that of J. R. Cozens, whose watercolours point the way to the magnificent essays in colour or works of 'pure poetry' which Turner did in the nineteenth century. Other painters romanticised the English landscape, concentrating particularly on the changing weather and atmosphere, whilst others such as Samuel Palmer interpreted the English landscape in a visionary way.

Jonathan Skelton (1735?-1759)

Jonathan Skelton began his career as a topographical watercolourist of picturesque views, including 'The Archbishop's Palace at Croydon' and 'The Ruins of Canterbury Castle'. He also produced more imaginative compositions such as 'Greenwich Park: A Fantasy and a Part of Blackheath' (1757). Skelton was working in Croydon in 1754 and in London and Rochester in 1757. After working in England within the topographical tradition Skelton went to Rome in 1757 and we know from letters written home to William Herring of Croydon that he was greatly influenced by the landscapes of Claude and Gaspar Dughet (Poussin). 'This ancient city of Tivoli I plainly see has been ye only school where our two most celebrated landscape painters Claude and Gaspar studied', he wrote, and also: 'you desired to know in your letter dated the 10th July, whether I imitate Claude, or Poussin or both ... Mr Light ... thought that I was something in Claude's manner' (Tivoli, 20th August 1758).

The influence of Poussin may be clearly seen in two of Skelton's most successful compositions of the subject 'Lake Albano and Castel Gandolfo', one of which is in the Whitworth Art Gallery at the University of Manchester and the other in the Ashmolean Museum, Oxford.

Francis Towne (c 1739-1816)

Francis Towne was one of the first artists to go to Switzerland and paint the beautiful alpine scenery. His highly individual style has sometimes been compared to the art of a Japanese print. In one of his most successful works, 'The Source of the Arveyron', he showed his ability to reduce the awesome alpine scenery into a few simple shapes without losing its magnificence. Similarly his work 'Trees in Peamore Park' (now in the Whitworth Art Gallery, Manchester) and other studies of trees show his ability to portray trees by reducing them to abstract patterns and shapes.

Towne returned to Britain in 1781 and in 1786 he made a tour of the Lake District. After 1786, apart from Welsh and Grand

Tour subjects, Towne mostly exhibited views of Devon (Pea-more Park is a few miles from Exeter). Albums containing watercolours from his earlier Italian trips and which included sketches made around Tivoli and the Alban hills were given to the British Museum in 1816 and these contain a number of exceptionally beautiful studies.

From 1807 until his death in 1816 Towne lived permanently in London. His failure to become an Associate of the Royal Academy in 1805 affected his subsequent work, which was never as inspired as his earlier paintings.

Alexander Cozens (c 1717-86)

Alexander Cozens was an important and influential figure in the history of the English watercolour, both for his paintings and for his writings, particularly his ideas about painting original landscapes from accidental 'blots' and about how to depict trees. His work shows an unusual sensitivity to the effects of weather, especially clouds and sunshine. He tended to simplify his landscapes, including no human figures and paying special attention to the patterns of light and shade. He passed on these qualities to his son John Robert, who imbued his work with an additional feeling of lyricism.

Alexander Cozens was born in Russia and studied in Italy. When he returned to England his patron and friend was the extravagant and eccentric William Beckford. From 1763 to 1768 he was drawing master at Eton. 'On a Country Road' is an example of one of his early watercolours. It is painted entirely in transparent colour over a faint pencil outline. Cozens shows in this and in other early work his desire to reproduce the exact details and colours of the subjects, most of which were topographical and done in Italy. Many of them were pretty and this feature was emphasised by the colour he used.

His other work was mostly executed in black and white with grey washes and he wrote detailed analyses of his working methods, some of which were highly inventive and imaginative. His later drawings show him to have been a follower of Claude in the romantic classical tradition. He had a feeling both for grandeur of design and for atmosphere.

Alexander Cozens wrote extensively and he considered his writings were of greater consequence than his artistic work. He published *The Shape, Skeleton and Foliage of 32 Species of Trees for the Use of Painting and Drawing* in 1771 and *A New Method of Assisting the Invention in Drawing Original Compositions of Landscape* in 1786. This work described how to create a landscape by first starting with a blot. This was a variation of an idea of the fifteenth-century Italian painter Leonardo to stimulate the mind by imagining landscapes, rocks and the like from

accidental stains or marks. However, Cozens thought that his own ideas were superior to Leonardo's!

The general idea behind most of Cozens's work was to see landscape in masses, shapes and forms rather than in terms of line. This is particularly noticeable in his later work. His treatment of landscape and trees may be seen in the work 'Woodland Scene with Thorn Trees'. He also made a particular study of cloud formations.

In his writing and in his painting Alexander Cozens influenced his son, John Robert, greatly, particularly in his methods of composing landscapes and his innumerable studies of clouds. Skies became a vital part of Alexander's work and he used them to express the mood of a landscape, and this was a characteristic of his son's work too. Alexander's simplification of forms was also something which we find in his son's work, particularly in his treatment of the majestic alpine scenery.

John Robert Cozens (1752-97)

John Robert Cozens was one of the most important and gifted of the eighteenth-century watercolourists who worked in the romantic tradition. His father, Alexander Cozens, taught him about landscape drawing and different methods of composition. John Robert Cozens may be seen as a link between the topographical artists like Sandby and the poetic tradition as practised by Girtin and Turner, both of whom made many copies of John Robert Cozens's work and were profoundly influenced by it. Constable made a particular study of Cozens's skies and cloud formations which inspired his own work. Cozens was inventive in both composition and technique. He was one of the first watercolourists to give a hint of colour to his work and this feature combined with his striking rendering of skies helped to evoke mood and a feeling of lyricism, a quality hitherto absent from English watercolours.

Cozens made his first journey to Italy from 1776 to 1779, aided by his patron Richard Payne Knight. He made his second visit to Italy as a draughtsman to the rich and eccentric William Beckford from 1782 to 1783 and most of his watercolours are of alpine scenery and Italian landscape. On this tour he made over two hundred studies contained in seven sketchbooks which are one of the most complete visual records of a typical eighteenth-century Grand Tour. The works trace their route from the valleys approaching Innsbruck through Brixen and Bolzano to Verona, followed by a stop of several days at Padua, then rapidly on through Rome and by way of Terracina finally to Naples. Four of the books are filled with sketches made in the region of Naples, which was widely explored by Cozens between late July and early December 1782, when he visited Vietri, Salerno and

Paestum. A watercolour of 'The Coast between Vietri and Salerno, 1782' shows his sensitivity to the atmosphere and light of the scene. Cozens stayed in Rome from December 1782 to September 1783 and the homeward journey from there took him through Florence, the shores of Lake Maggiore and the Grande Chartreuse. It was this same area of the Alps which was to affect Turner so deeply nearly twenty years later and which to some extent he saw through the eyes of John Robert Cozens.

When Beckford left Naples for Marseilles he left Cozens behind, 'once more a free agent and loosed from the shackles of fantastic folly and caprice'. Cozens made repeated versions of the most popular views such as those of Lake Albano and Lake Nemi as they sold well with patrons. His subjects also included the Villa d'Este, Tivoli and Paestum. One of the paintings he did of Lake Nemi looking towards Cenzano is in the Whitworth Art Gallery in the University of Manchester. This tranquil scene shows Cozens's ability for inventive composition and talent for evoking mood.

Another watercolour by Cozens called 'In the Garden of the Villa Negroni at Rome' shows his ability to portray trees as living organisms rather than as stylised forms, which is how many eighteenth-century topographical artists such as Sandby depicted them. This picture was described in Beckford's sale catalogue of 1805 as a 'picturesque scene, tinted in a rich and brilliant tone'. His interest in trees was stimulated by his father's writings and John Robert Cozens had copied some of his father's watercolours which had included trees.

Other works by John Robert Cozens, such as 'Mountains on the Isle of Elba', show his ability to handle light as well as to portray mountains in a highly picturesque and romantic way, by simplifying the forms and seeing them in terms of form and mass. He also shows his ability to depict skies and clouds so that they appear to be the enveloping atmosphere of the mountains. From 1794 he suffered serious mental disorders and was placed in the care of Dr Thomas Monro for the last years of his life. A hint of melancholy may be seen in his watercolour done in 1782 of Padua, and similarly 'Ruins of Paestum', a watercolour which he painted in 1782, also shows a great ability to portray cloud formations and a dramatic foreboding sky.

No other eighteenth-century artist surpassed Cozens in his feeling for poetry and his ability to portray romantic landscape. His work greatly influenced the next generation of English watercolourists, namely Girtin, Turner and Constable.

Thomas Girtin (1775-1802)

Thomas Girtin was born in London in the same year as Turner. Because of his early death his original talent as a

watercolourist has never been fully recognised and he has been overshadowed by Turner. Yet Turner himself recognised the immense skill of Girtin, in works such as 'The White House, Chelsea', saying 'Had Tom have lived I would have starved', and Joseph Farington recorded in his diary of 9th February 1799: 'Hoppner told me Mr Lascelles as well as Lady Sutherland are disposed to set up Girtin against Turner — who they say effects his purpose by industry — the former more genius — Turner finishes too much.'

In 1788 Girtin was apprenticed to the topographical water-colourist Edward Dayes, and he stayed with him for three years. In 1794 he accompanied the antiquarian publisher James Moore on a tour of the Midlands and both Turner and Girtin went to study and copy works of other watercolourists at Dr Monro's house. They were both chiefly employed on studying and copying drawings by John Robert Cozens, and Girtin also copied architectural compositions after Thomas Malton the younger, Piranesi and Marco Ricci.

Girtin exhibited his work at the Royal Academy for the first time in 1794 and continued exhibiting there until 1801, a year before his death. In 1796 Girtin toured the north of England and Scottish border country, in 1797 the south-western counties and in 1798 North Wales. From a pencil sketch which he made on his first visit to Durham in 1796, Girtin completed the work entitled 'Durham Cathedral and Bridge from the River Wear' in 1799. The minute detail in this work shows how Girtin had become a master of the topographical watercolour, with immense skill as an architectural draughtsman. The work shows the influences of Thomas Malton the younger, Piranesi, Marco Ricci and Canaletto, as well as his early master Edward Dayes.

Girtin's training as a topographical watercolourist seems to have exercised some influence on his choice of subject matter for most of his life. For instance, like many artists before him he was inspired by London's riverside. Hollar had been the first to depict views from the Thames and he was followed by many other topographical painters including Canaletto and Paul Sandby. Girtin produced a panorama of London under the title 'Eidometropolis', which he exhibited at Spring Gardens in August 1802, three months after his return from Paris and shortly before his death. Five watercolour views and two drawings have survived, all of which are preparatory studies for 'Eidometropolis' and represent sections of the circular panorama as viewed from a point close to the south end of Blackfriars Bridge.

In 1798 Girtin was giving tuition to Edward, Viscount Lascelles, of Harewood House in West Yorkshire and he became Girtin's patron. Girtin probably paid annual visits to

Harewood House from this date and a pencil drawing of Harewood House in the Girtin sketchbook in the Whitworth Art Gallery is dated 1800 and it was probably around this time, or a little earlier, that he completed 'The Gorge at Watendlath with the Falls of Lodore, Derwentwater'. In the latter part of the eighteenth century areas of natural beauty like the Lake District became more popular and especially appealed to the romantic temperament of artists like Girtin. Girtin's work presents a romantic view of the waterfall, which became a popular subject with other artists such as Cozens and Towne.

Girtin's sketching club was formed in May 1799 and after this date his interest in light and atmosphere resulted in a marked change in his style and use of colour. This change can be clearly seen in one of the works which Turner so admired, 'The White House, Chelsea', which he finished in 1800. The feeling for atmosphere and light are the most striking features of this work.

Girtin's only continental visit was to Paris, where he stayed from November 1801 to May 1802. He had been advised to go there because of his failing health and he completed a large number of drawings whilst he was there. As many of them were of various views of the city and its surrounding countryside it is thought that he might have intended to paint a panorama of Paris, similar to the one he did of London. Two of the finest watercolours which resulted from this visit are 'La Rue St Denis, Paris', now in a private collection, and the 'Porte St Denis', now in Victoria and Albert Museum. The impressionistic way in which Girtin has treated the buildings is the most notable feature of these works.

In the last two years of his life a strong sense of isolation and solitude became evident in his work. Many of his last pictures depict bare ranges of hills, bleak river valleys, cascades, estuaries and headlands and extensive tracts of open countryside. Often they are devoid of human figures or, if there are any, the figures are dwarfed by the landscape. Many of these works show an exceptional power of creating mood and atmosphere and a feeling of pessimism which must have echoed to some extent Girtin's own state of mind at that time. One of the most evocative works from this period is 'Storith Heights, Wharfedale, Yorkshire', which shows Girtin's originality as a watercolourist in the romantic tradition. In 'Tynemouth, Northumberland' he chose a beach scene, a subject which did not become popular until later in the nineteenth century, and its broad treatment and scientifically observed sky is, in Martin Hardie's words, 'so impressive in its rendering of the stark headland, the lonely stretch of sands, the dark and swollen clouds pregnant with rain'. Works such as these equalled, some would say surpassed, those of his contemporary, Turner. Certainly Girtin

was one of the most talented of English watercolourists.

Joseph Mallord William Turner (1775-1851)

Ruskin, the nineteenth-century art critic, enthused about Turner in his book *Modern Painters* and called him 'the most perfect landscape artist that has ever lived'. Turner's vast output includes over nineteen thousand watercolours and over three thousand oil paintings. He began as a topographical artist making meticulous detailed drawings of buildings often tinted with blue-grey washes, but he soon began to concentrate on evoking the atmosphere of buildings such as Tintern Abbey by using dramatic contrasts of light and shade and this was something new in the eighteenth-century topographical tradition. He went on regular sketching tours all over England and Scotland and in Yorkshire he produced, in Ruskin's words, drawings 'with the most heart in them'. Turner was also inspired by the French seventeenth-century painter Claude, particularly in Claude's choice of subject matter and the way in which he composed his landscapes. J. R. Cozens and Turner's contemporary Girtin also influenced his early style and when Turner first visited the Alps in the early nineteenth century the way he saw the scenery was strongly affected by the work of J. R. Cozens. But by the 1840s Turner had developed his own style and produced works of the area around Lake Lucerne in Switzerland which are considered to be 'his crowning achievement in watercolour'.

But it was in Venice that Turner painted some of his most exquisite watercolours and first used a brighter palette which included the scarlet, blue and yellow colours for which he is famous. He also exploited every aspect of the watercolour technique: he used different-coloured papers; he used bread 'to stop out' so that the brilliant white of the paper was used to express light; he would often let one wash blur into another and he would incorporate 'accidents' such as blots and thumbprints into his work. Farington said of his technique that 'he drove the colours about till he has expressed the idea in his mind'. Towards the end of his career Turner had combined a free technique with a penchant for producing works which are almost abstract essays of colour and light, where form is scarcely visible and where the subjects are mostly sunrises and sunsets. Although Turner kept some of these 'colour beginnings' firmly from the public eye, some of his exhibited work was still too abstract for some people, notably Hazlitt, who saw his work as 'portraits of nothing and very like'. However, he had the support of Ruskin, his patrons Walter Fawkes and Lord Egremont and the Royal Academy and today he is rightly regarded as one of the finest of English painters.

According to the diarist Joseph Farington, Turner became, at the age of fourteen, a pupil of Thomas Malton, a topographical watercolourist who specialised in architectural subjects. Turner's precocious genius was such that he first exhibited at the Royal Academy in 1790 and was elected an Associate at the earliest possible age in 1799 and a Member in 1802.

In the early 1790s Turner was working within the eighteenth-century topographical tradition, making drawings of Gothic buildings such as Salisbury Cathedral and the Bishop's Palace, Salisbury, and using faint blue-grey washes of colour over a detailed drawing. This style was close to that of his friend and contemporary Thomas Girtin.

For several years between 1794 and 1797 Turner and Girtin often worked together in the evenings at Dr Monro's house copying watercolours by Edward Dayes and John Robert Cozens for him. In 'Tintern Abbey', exhibited at the Royal Academy in 1794, Turner shows his ability to depict a building in a picturesque way rather than keeping within the tight topographical tradition.

At the height of his fame in 1802 Turner went to Switzerland, where the extremes of nature such as the thunderstorms, avalanches, waterfalls and other aspects of the spectacular mountainous scenery had a profound effect on his romantic temperament. Some of the best drawings which resulted from this trip were done in opaque watercolour on grey paper. 'The Mer de Glace: View of Chamonix with Blaire's Hut' is a good example. However, it was later in the 1840s when he produced his best works of Switzerland and those he did then of the area around Lake Lucerne are superb.

Turner's original style was developed further after he had visited Venice for the first time in 1819. The first sketches were mostly made in pencil. However, on his return, from the 1820s onwards, the quiet and silvery tones of his early period were giving way to reds, yellows and blues. This more colourful palette was a direct result of his Italian trip. Venice, with its freedom of space, brilliant light, simple forms and low skyline, was a new and exciting inspiration to Turner. The reflections of buildings, such as the beautiful dome of the Santa Maria della Salute, in the water and the way in which the buildings seemed to disappear into the skyline, particularly at dawn and sunset, were something which Turner was able to relate to. Similarly the effects of the dazzling light, also particularly at dawn and sunset, stimulated Turner to portray them. In this respect his approach differed greatly from that of Canaletto, who recorded the buildings, the canals and the colourful processions and pageants of Venice with intricate details, almost photographically.

On his second visit to Venice he began to work rapidly in

bodycolour on grey or brown paper. His final visit to Venice was in 1840 and from this visit came 'Storm at Sunset', 'Calm at Sunrise' and 'Calm at Sunset'. It was said of Turner that he had seen the sun rise more often than the rest of the members of the Royal Academy put together. Unlike Constable, who chose to portray his landscape at midday or early afternoon, Turner with his romantic temperament painted his subjects at dawn or at sunset when the sky was at its most majestic. The light and the hot pinks and reds found in these works were a direct inspiration from Venetian dawns and dusks. His paintings were becoming descriptive visions of vivid colour and light and human figures and buildings became blurred and almost indistinguishable.

After his final visit to Venice in 1840 Turner had abandoned tinted paper and bodycolour and used the white of the paper to portray even more dazzling and luminous light by painting, both in watercolour and oil, on thin transparent paper so that the white of the paper shone through. His late work provoked a great deal of controversy as it became more abstract and the colour more vivid. But it is in his use of colour that Turner was a revolutionary, as hitherto watercolour had always been used either as a tint wash or as a stain and blues, greys and browns were the chief colours used — only J. R. Cozens had used a hint of pink in his works. Turner's use of vibrant colour was something entirely new in English watercolour and his use of colour shows his originality and inventiveness. Turner's work, including his magnificent sea pieces, had a lasting influence on nineteenth-century watercolourists, both in their choice of subject and in their technique.

John Constable (1776-1837)

John Constable did his watercolours for pleasure and as preliminary studies of various natural and weather effects which he was later to use in his oil paintings. In particular he found it a highly suitable medium to depict varying cloud formations. He rarely exhibited his watercolour work and he kept the very free watercolours, which included his innumerable cloud studies, firmly from the public eye. He viewed most of his work in watercolour as a form of shorthand and a source he could draw from to use in his work in oil. As he never regarded most of his watercolours as pictures in their own right, it was several decades after his death that his importance as a watercolour painter was fully appreciated.

Constable was born in East Bergholt on the borders of Suffolk and Essex, overlooking the lush valley of the river Stour. 'The sound of water escaping from mill dams, willows, old rotten plants, slimy posts and brickwork — I love such things. These scenes made me a painter, and I am grateful', he wrote. Indeed

most of his best work was inspired by this landscape and it was Constable's superb achievement that he was able to make this natural scenery a subject for a painting in its own right.

In 1811, instead of imitating other painters or concentrating on portraits, which were nevertheless a valuable source of income to him, Constable did several oil sketches of the Stour. These are examples of pure naturalistic landscape *par excellence*. Previously seventeenth-century Dutch painters had depicted pure landscape without a subject and a few French artists such as Moreau and Granet had also produced pure landscape work but none had been able to depict the effects and contrast of light and shade in the landscape with the immediacy and freshness which Constable showed in these early Stour works. In this sense Constable was the first painter of landscape to depict the expressive qualities of nature in an understated way by the clever juxtaposition of light and shade.

Although in the 1820s the subjects of his large works in oil, such as 'The Haywain' and 'Bridges on the Stour', were all inspired by the scenery on and around the river Stour, he also visited his friend Archdeacon Fisher in Salisbury. He began in 1821 'The Old Houses, Harnham Bridge, Salisbury', which was completed in watercolour in 1831. This work shows how Constable developed his own style and how successful he was in conveying the movement of sky and the contrasts of gloom and silvery light. All over the drawing (this is characteristic of his later work) specks of light have been flicked out with the point of a sharp penknife. This picture demonstrated what Constable called 'the chiaroscuro of nature'. To some extent Constable was referring to the piece of advice given to him by Benjamin West, 'Remember, light and shade never stay still', but Constable also felt that light and shade should be used in such a way as to provide a keynote of drama in the landscape composition. Constable perhaps also included dramatic contrasts of light and dark in his work as an indication of how he viewed human experience.

Although many people believe that after his wife's death Constable's work in oil lost its freshness of vision and seems contrived and unnatural, he did some of his finest work in watercolour during the period 1828-34. The qualities which he aimed to convey in his work were light, dews, breezes, bloom and freshness and these may all be seen in the watercolour of 'Old Sarum in Storm' (1828). This was in Martin Hardie's words a 'vibrant breezy sketch all moist with rain under swollen clouds, full of the weather which comes between the thunder and the sun'. However, the larger 'Old Sarum' which was exhibited in 1834 was more contrived and less successful.

Another watercolour from this period is 'Fittleworth Bridge

and Mill, Sussex' (1834), which was sketched in pencil and chalk with a scheme of grey and silver with touches of madder on the buildings and is one of the most perfect and spontaneous of Constable's watercolours. Other notable watercolours from this period include those he did of Hampstead Heath, which many see as anticipating impressionism in their technique.

Constable's desperate melancholy, which reflected his personal state of mind, was expressed magnificently in the large watercolour of Stonehenge which was exhibited at the Royal Academy in 1834, although the small study which he did of it is perhaps more successful and not so 'finished'. Constable wrote a most suitable description of the work on the mount: 'Still the darkness is majestic. No trees, no cornfields, no canals, only the ancient stones defying the elements as much unconnected with the events of the past ages as with the uses of the present.' The painting demonstrates magnificently the dramatic contrasts of light and shade which Constable regarded as the basis of composition and these dramatic contrasts seem to echo the mysterious presence of the stones. The dramatic sky also helps to echo the mood of the work and shows how Constable never painted a sky like a sheet hung behind his trees and buildings nor like 'the white sheet behind a landscape' of which Reynolds spoke. Constable saw the sky as a deepening and extension of the enveloping atmosphere of the landscape. This is particularly true of his cloud studies. Constable had studied Luke Howard's classification of clouds and John Robert Cozens's cloud studies. On the back of his cloudscapes Constable wrote the time of year, the hour of the day and the direction of the wind and when they were painted. Undoubtedly they show Constable's supreme talent of painting the fleeting movements of clouds and skies and these studies were to form an integral part of all of his work, including the large oil canvases of outdoor scenes for which he is famous. These cloud studies alone show Constable to be a fine watercolourist.

John Crome (1768-1821)

Two of the most talented artists who formed the Norwich School were Crome and Cotman. They specialised in depicting Norfolk scenery and their work ranks highly among other English artists of this period. John Crome was a leading figure in the founding of the Norwich Society of Artists in 1803. He became president of the society in 1808 and exhibited at the Royal Academy in 1806 and at intervals up to 1818. The landscapes of Hobbema, Gainsborough and Wilson played an important role in the development of Crome's style and he specialised mainly in Norfolk heath scenes, wooded landscapes and river and coastal views, which entailed a great deal of

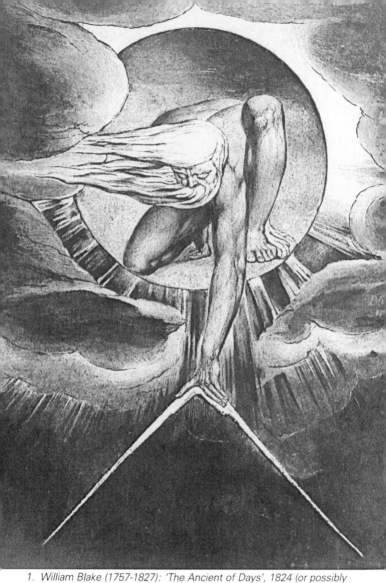

1. William Blake (1757-1827): 'The Ancient of Days', 1824 (or possibly 1826). Watercolour, bodycolour, black ink and gold paint over a relief etched outline printed in yellow; 9¼ by 6⅝ inches (234 by 168 mm). (Whitworth Art Gallery, University of Manchester.)

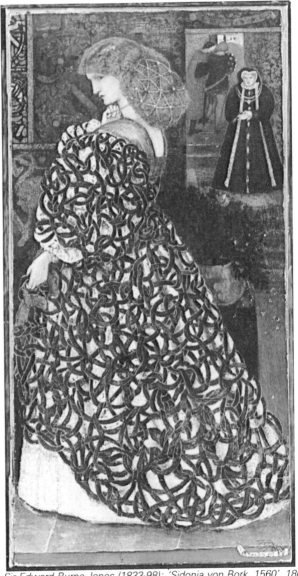

2. Sir Edward Burne-Jones (1833-98): 'Sidonia von Bork, 1560', 1860.
Watercolour; 13 by 6¾ inches (330 by 171 mm). (Tate Gallery, London.)

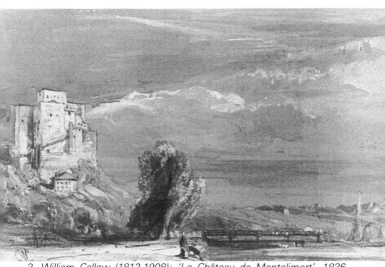

3. William Callow (1812-1908): 'Le Château de Montelimort', 1836. Watercolour; 5¼ by 9¼ inches (133 by 235 mm). (Cecil Higgins Art Gallery, Bedford.)

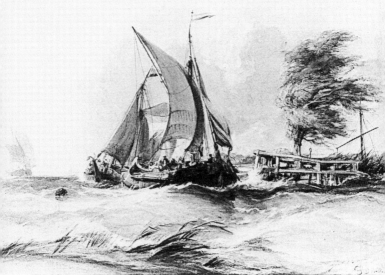

4. George Chambers (1803-40): 'A Windy Day: Boats in a Gale'. Watercolour; 9⅜ by 14⅛ inches (238 by 359 mm). (Victoria and Albert Museum, London.)

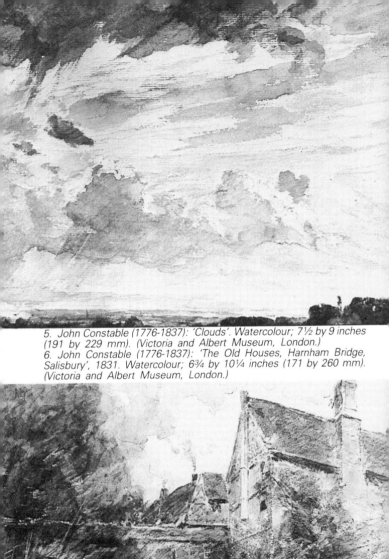

5. John Constable (1776-1837): 'Clouds'. Watercolour; 7½ by 9 inches (191 by 229 mm). (Victoria and Albert Museum, London.)
6. John Constable (1776-1837): 'The Old Houses, Harnham Bridge, Salisbury', 1831. Watercolour; 6¾ by 10¼ inches (171 by 260 mm). (Victoria and Albert Museum, London.)

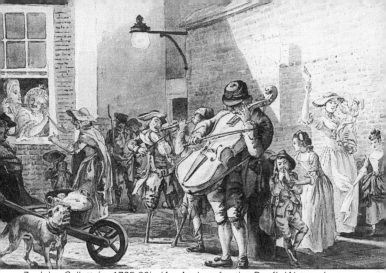

7. John Collett (c. 1725-80): 'An Asylum for the Deaf'. Watercolour; 13¾ by 21⅛ inches (349 by 537 mm). (Victoria and Albert Museum, London.)

8. John Sell Cotman (1782-1842): 'The Dismasted Brig'. Watercolour; 7⅞ by 12¼ inches (200 by 311 mm). (British Museum, Department of Prints and Drawings, London.)

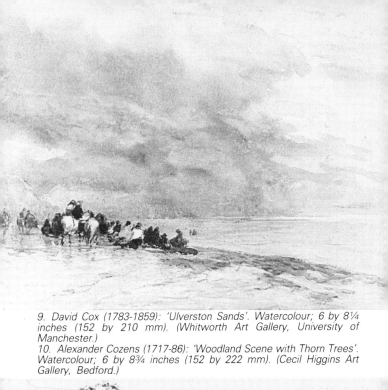

9. David Cox (1783-1859): 'Ulverston Sands'. Watercolour; 6 by 8¼ inches (152 by 210 mm). (Whitworth Art Gallery, University of Manchester.)

10. Alexander Cozens (1717-86): 'Woodland Scene with Thorn Trees'. Watercolour; 6 by 8¾ inches (152 by 222 mm). (Cecil Higgins Art Gallery, Bedford.)

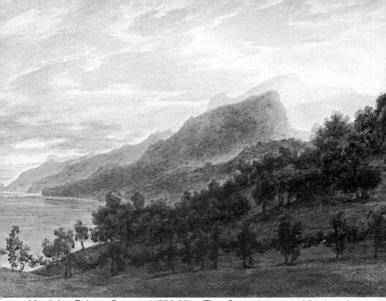

11. John Robert Cozens (1752-97): 'The Coast between Vietri and Salerno', 1782. Watercolour; 10⅛ by 14⅝ inches (257 by 371 mm). (Cecil Higgins Art Gallery, Bedford.)

12. Walter Crane (1845-1915): 'Pan Pipes'. Pen and watercolour; 7½ by 10 inches (190 by 254 mm). (British Museum, Department of Prints and Drawings, London.)

13. Edward Dayes (1763-1804): 'Lympne Castle'. Watercolour; 17¼ by 21½ inches (438 by 546 mm). (Laing Art Gallery, Newcastle upon Tyne.)
14. Myles Birket Foster (1825-99): 'Lane Scene at Hambledon'. Watercolour; 16¾ by 25 inches (425 by 635 mm). (Tate Gallery, London.)

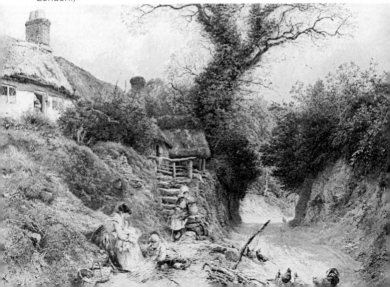

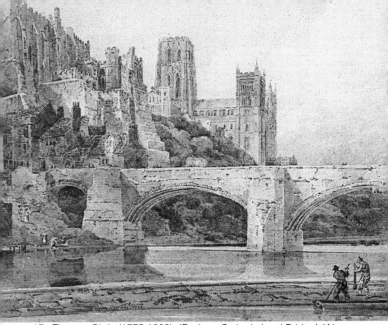

15. *Thomas Girtin (1775-1802): 'Durham Cathedral and Bridge'. Water-colour with faint pencil and scratching out; 16⅜ by 21⅛ inches (416 by 537 mm). (Whitworth Art Gallery, University of Manchester.)*

16. *Thomas Girtin (1775-1802): 'Storith Heights, Yorkshire'. Water-colour; 11⅛ by 16⅜ inches (283 by 416 mm). (Tom Girtin Esq.)*

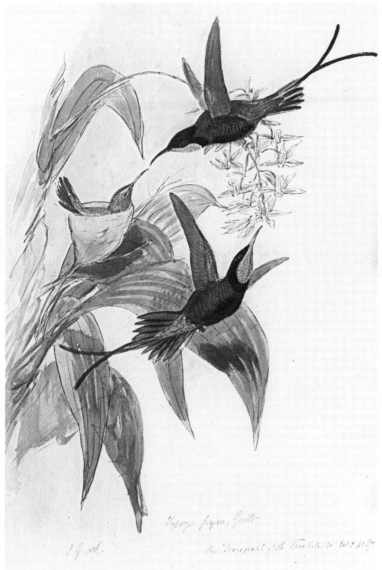

Topaza pyra, Gould.

J. G. del.

...Bonaparte of the Trochilidæ W.S.p...

17. John Gould (1804-81): 'Hummingbirds'. Pen and watercolour; 21 by 14 inches (533 by 357 mm). (Private collection.)

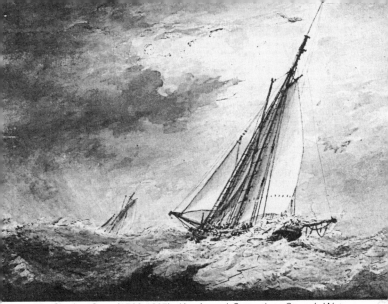

18. Charles Gore (1729-1807): 'An Armed Cutter in a Storm'. Water-
colour and some bodycolour; 7⅜ by 10⅜ inches (187 by 264 mm).
(British Museum, Department of Prints and Drawings, London.)
19. Kate Greenaway (1846-1901): 'Dance of Four Little Maids with
Lambs'. Pencil and watercolour; 4 by 5⅞ inches (102 by 149 mm).
(Ashmolean Museum, Oxford.)

20. William Henry Hunt (1790-1864): 'The Maid and the Magpie'.
Watercolour; 17⅜ by 22⅜ inches (441 by 568 mm). (Cecil Higgins Art
Gallery, Bedford.)
21. Julius Caesar Ibbetson (1759-1817): 'The Market'. Watercolour;
8½ by 11½ inches (216 by 292 mm). (Laing Art Gallery, Newcastle
upon Tyne.)

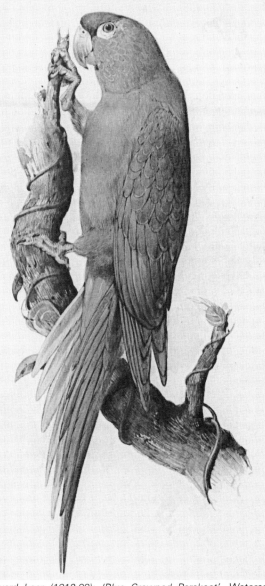

22. Edward Lear (1812-88): 'Blue Crowned Parakeet'. Watercolour over pencil with gum; 21 by 14⅜ inches (533 by 365 mm). (Private collection.)

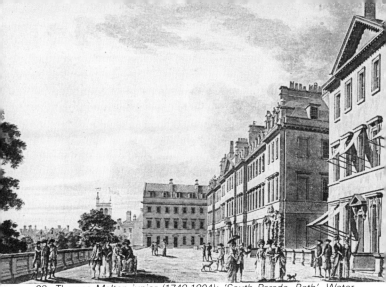

23. Thomas Malton junior (1748-1804): 'South Parade, Bath'. Water-colour over pen and ink; 12¾ by 18½ inches (324 by 470 mm). (Victoria Art Gallery, Bath City Council.)

24. John Frederick Lewis (1805-76): 'Life in the Harem'. Watercolour; 23⅞ by 18¾ inches (606 by 476 mm). (Victoria and Albert Museum, London.)

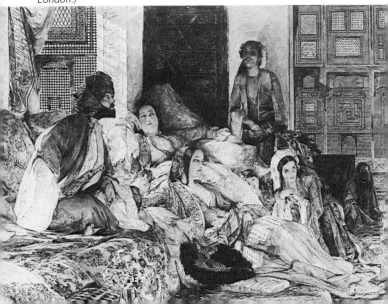

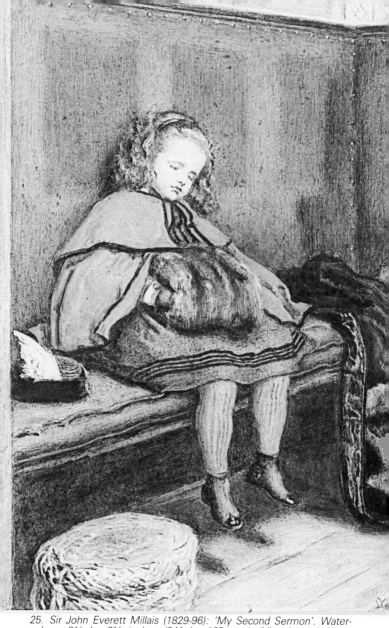

25. *Sir John Everett Millais (1829-96): 'My Second Sermon'. Water-colour; 9½ by 6½ inches (241 by 165 mm). (Victoria and Albert Museum, London.)*

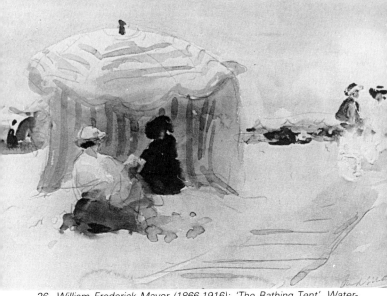

26. *William Frederick Mayor (1866-1916): 'The Bathing Tent'. Watercolour; 10¼ by 14 inches (260 by 356 mm). (Laing Art Gallery, Newcastle upon Tyne.)*

27. *Paul Nash (1889-1946): 'Gloucester Valley', c. 1943. Watercolour; 14¾ by 21¾ inches (375 by 552 mm). (Cecil Higgins Art Gallery, Bedford.)*

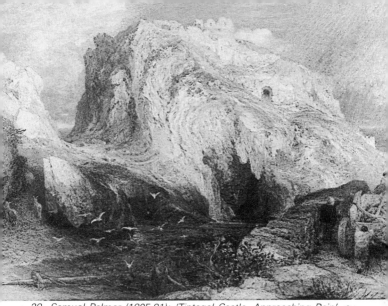

28. Samuel Palmer (1805-81): 'Tintagel Castle, Approaching Rain', c. 1849. Watercolour and bodycolour, mixed with gum arabic over pencil and black chalk; 11⅞ by 17¼ inches (302 by 438 mm.) (Ashmolean Museum, Oxford.)

29. Nicholas Pocock (1741-1821): 'Eastbourne, Sussex'. Watercolour; 12⅞ by 17¾ inches (327 by 451 mm). (British Museum, Department of Prints and Drawings, London.)

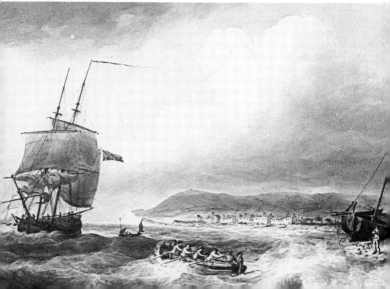

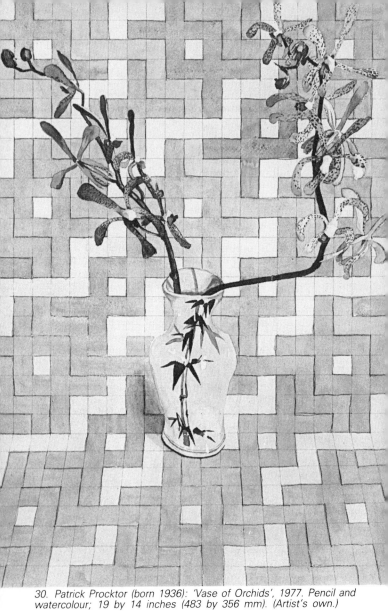

30. Patrick Procktor (born 1936): 'Vase of Orchids', 1977. Pencil and watercolour; 19 by 14 inches (483 by 356 mm). (Artist's own.)

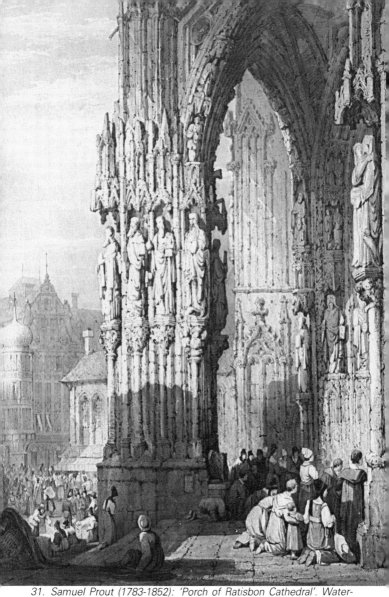

31. Samuel Prout (1783-1852): 'Porch of Ratisbon Cathedral'. Water-colour; 25¾ by 18¼ inches (654 by 464 mm). (Victoria and Albert Museum, London.)

32. Alan Reynolds: 'Teazles'. Pen and watercolour; 23¼ by 13⅜ inches (591 by 340 mm). (Cecil Higgins Art Gallery, Bedford.)

33. *Dante Gabriel Rossetti (1828-87): 'Dante Drawing an Angel on the Anniversary of Beatrice's Death'. Watercolour; 16 by 24½ inches (406 by 622 mm). (Ashmolean Museum, Oxford.)*

34. *Thomas Rowlandson (1756-1827): 'Entrance to the Mall'. Pen and ink and watercolour; 13¼ by 18⅝ inches (337 by 474 mm). (Victoria and Albert Museum, London.)*

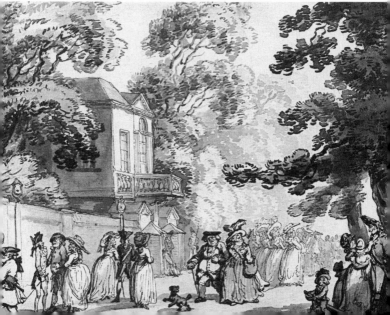

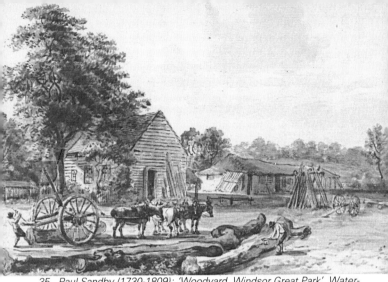

35. Paul Sandby (1730-1809): 'Woodyard, Windsor Great Park'. Water-colour; 7 by 10¾ inches (178 by 273 mm). (British Museum, Department of Prints and Drawings, London.)

36. Jonathan Skelton (1735?-59): 'Lake Albano and Castel Gandolfo'. Watercolour; 14½ by 20⅞ inches (368 by 530 mm). (Ashmolean Museum, Oxford.)

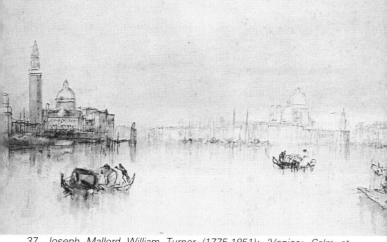

37. *Joseph Mallord William Turner (1775-1851): 'Venice: Calm at Sunrise'. Watercolour; 9 by 13 inches (229 by 330 mm). (Fitzwilliam Museum, Cambridge.)*

38. *Joseph Mallord William Turner (1775-1851): study for 'The Shipwreck'. Watercolour; 17 by 25½ inches (432 by 648 mm). (British Museum, Department of Prints and Drawings, London.)*

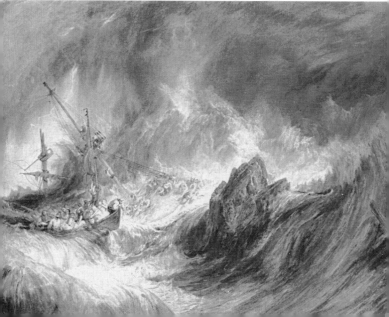

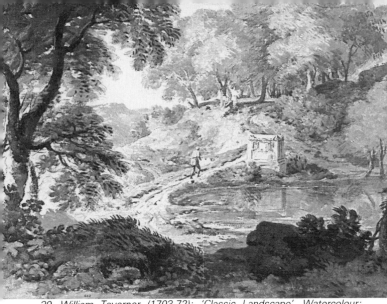

39. William Taverner (1703-72): 'Classic Landscape'. Watercolour; 12¾ by 17⅞ inches (324 by 454 mm). (Victoria and Albert Museum, London.)

40. Peter de Wint (1784-1849): 'Gloucester Cathedral with Ruins of St Catherine's Church'. Watercolour; 11¼ by 18 inches (286 by 457 mm). (Cecil Higgins Art Gallery, Bedford.)

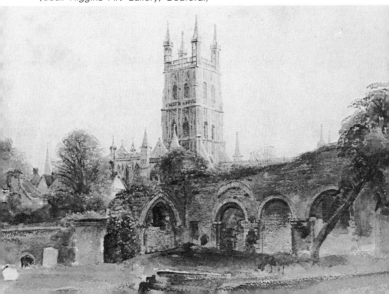

outdoor sketching. He did not travel very much and apart from a visit to the Lake District and a journey to Paris in 1814 most of his work was inspired by Norfolk scenery. Unlike Cotman, Crome did few works in watercolour and instead preferred to work in oil. As his style and work was copied a great deal it is very difficult to decide exactly which work is by him.

'The Blasted Oak' (23 by 17¼ inches, 580 by 440 mm), now in a private collection, is one of Crome's finest watercolours and shows his ability to paint a tree so that it appears to have individual character and looks alive. The use of the fence, the bare tree trunk and twisted branches, as well as the simple qualities of colour, are features which recur in Crome's work. Other important drawings by this artist include 'Blacksmith's Shop, Hingham' at the Castle Museum, Norwich, and 'Wood Scene' in the Victoria and Albert Museum. Crome died in Norwich in 1821.

John Sell Cotman (1782-1842)

Cotman was born in Norwich, the son of a barber and a haberdasher. In 1798 he moved to London, where he worked for the print dealer Ackermann, and he later entered the circle of Dr Monro and became one of his copyists a few years after Girtin.

Cotman visited Bristol and Wales in 1800 and probably returned to Wales in 1802. He visited Yorkshire in three successive years between 1803 and 1805, staying with the Cholmeleys of Brandsby Hall and in 1805 also with the Morritts at Rokeby Park. This house was on the river Greta and in a letter written from the inn at Greta Bridge to the younger Francis Cholmeley on 29th August 1805 Cotman writes: 'All my studies have been in the woods above Greta Bridge . . . I think it grows upon me in regard every day, it really is a delicious spot.' This area became the greatest source of inspiration for Cotman, whose paintings of it are some of the finest English watercolours. Although this inspiration returned later in his life it appeared only in flashes. Cotman was troubled by his own melancholy and lack of public support and his later work does not have the same consistent brilliance as the early watercolours.

An example of a watercolour produced in the early period is 'On the River Greta, Yorkshire', in the Castle Museum, Norwich, which also possesses two pencil drawings related to this composition. This picture and the others which he painted around the same area reveal a highly original approach to nature as well as an ability to translate his view of nature into visual terms in an inventive way. Cotman's highly individual style shows the influence of no other artist, except perhaps that his breadth of treatment may owe something to Girtin. The most notable feature of this style is evident in this work and in others

in the way in which Cotman has portrayed nature in geometric terms as a series of abstract shapes and patterns. The foliage, rock formations and river are all abstracted to a few simple shapes so that the view is seen as a series of massive forms with detail omitted, rather than in a photographic way. The colour which Cotman uses helps to increase this impression and like the compositions it is highly individual. The sky is clear blue, contrasting with the pure white clouds. The light brown of the rock formations contrasts with the varying grey greens of the foliage and rocks next to it, while the reflection of the clear blue sky and the contrasting grey green is seen in the river. These contrasts of unusual tones of colour help to increase the geometric divisions evident in the work.

At infrequent intervals Cotman was able to produce paintings with the same technical strength as his early work of the scenery around the river Greta. An example is 'Dismasted Brig'. But flashes of brilliance such as this were few in the latter part of his life, the last eight years of which he spent as drawing master at King's College, London. Cotman died in London in 1842. His genius as a watercolourist was not appreciated in his lifetime, but undoubtedly his Greta pictures are amongst the most beautiful of English watercolours.

Samuel Palmer (1805-81)

It is not known when Samuel Palmer first went to Shoreham in Kent. It may have been 1825 or earlier, but he eventually settled there with his father and nurse in 1827. Constant visitors included George Richmond, Edward Calvert and Francis Oliver Finch. They called themselves 'the Ancients', a term which referred to their common interest in the ancient classical poets and painters. Despising the fashions and schools of painting of their own day, they preferred to immerse themselves in romantic visions of the past. They were inspired by classical literature such as the works of Milton and Homer, as well as by the countryside in and around Shoreham. Their aim was to reconcile creative imagination with a literal, almost scientific representation of nature. In this respect the Ancients anticipated the Pre-Raphaelites, who were to follow them almost a generation later.

Palmer's Shoreham works, painted between 1827 and 1835, are some of the most exquisite and original of English watercolours. They show that Palmer had great imaginative powers as well as an ability to translate his ideas into paint. He evolved his own watercolour technique, for which there are no real precedents. Palmer called Shoreham his 'valley of vision' and although his Shoreham works were inspired by actual scenes Palmer imbued them with mystery and magic so that they appear as visions. This is particularly true of the watercolour 'The Magic

Apple Tree', done in 1830 (now in the Fitzwilliam Museum, Cambridge). Palmer described the apples as 'a tremendous and utterly abnormal crop' and said that 'the whole is a conflagration of colour'. Certainly he captured these two features in the work and the colour is dazzling. There is a similar heightened feeling for nature in the works 'Pastoral with Horse Chestnut', which is in the Ashmolean Museum, Oxford, and 'In a Shoreham Garden', which is in the Victoria and Albert Museum, London. It is as if Palmer has led us into a secret garden that only he has seen.

Other works from this period include the exquisite and unique sepia drawings which are now in the Ashmolean Museum, Oxford. The Ashmolean also houses another lovely work from this period, 'The Bright Cloud', although it was done in oil and tempera on mahogany. On the back of this work Palmer has written 'a rustic scene'.

Most of the drawings from the Shoreham years, which Palmer referred to as visions, are extremely small: $7\frac{3}{8}$ by $9\frac{1}{8}$ inches (190 by 230 mm) is the average size. He evolved a special technique for them, using both pen and brush with sepia ink, then mixing it with gum and varnishing the finished work. These works show his preoccupation with twilight and with dawn. 'Early Morning', 'A Rustic Scene', 'The Skirts of a Wood' and 'Late Twilight' are some of the titles and most of them are dated 1825. They not only rely on the natural scenery of Shoreham for their inspiration but they are also partly inspired by literature. For example, on the mount of 'Late Twilight' Palmer has quoted from *Macbeth*, Act III, Scene III, 'The west yet glimmers with some streaks of day', while on the mount of 'The Valley Thick with Corn' Palmer has written the last four lines from Act II, Scene V, of *As You Like It*.

Later in the 1830s the visionary quality of his work gave way to a more realistic approach to landscape. Many people argue that all Palmer's work subsequent to the Shoreham pictures is inferior but this is very misleading. Works such as 'Farmyard, Princes Risborough', which he did in 1848, and 'Tintagel Castle, Approaching Rain' show him still to have been an artist of great inventive power. Similarly, his last works, which include etchings and monochrome drawings illustrating Virgil and Milton, for example, 'The Eastern Gate' in the Victoria and Albert Museum, show him to be an artist of exceptional talent. Palmer is one of the most imaginative of English watercolourists; he follows on the tradition of Blake and looks forward to the imaginative genius of Rossetti.

William Gilpin (1724-1804)

Although the Reverend William Gilpin was not a watercolour

painter, he had a great effect on the style of English watercolours between 1780 and 1820. He wrote a series of guidebooks to the English countryside, illustrated with aquatints after his own drawings. The drawings were designed so that an artist could produce a 'picturesque' watercolour by including specific features of landscape. Such features had appeared in the works of romantic painters such as Claude and may be discerned in many watercolours of landscape, particularly nineteenth-century works in the manner of Varley.

John Varley (1778-1842)

John Varley produced a great number of watercolours such as the one of Waltham Abbey in the Victoria and Albert Museum. Although competent, it shows that Varley was not an inspired artist, but he did exert influence and inspiration through his teaching and one of his outstanding pupils, who was to outstrip him in talent, was David Cox.

David Cox (1783-1859)

Cox became one of the members of the Old Watercolour Society in 1820 and helped to revitalise it. Hitherto many members like Varley had tended to paint with masters like Gaspar Dughet (Poussin) and Claude in mind and this had had a deadening effect on English watercolour. Cox, Peter de Wint and Copley Fielding through their individual styles and techniques made English watercolour seem more lively and original.

Cox was born at Deritend in Birmingham and he worked as an assistant scene painter in Birmingham before moving to London in 1804. Varley became not only his teacher but also his friend and Cox's early work was done in a formal, picturesque style which showed the influences of both Varley and Poussin. His sister lived in Manchester and Cox went there fairly frequently, and in 1834 he made a tour of Derbyshire, Cheshire and Lancashire. Earlier, in 1802, he had visited Wales. However, after 1834 he seems to have favoured various locations near the coast of Morecambe Bay, including Ulverston Sands, Lancaster Sands and Hest Bank.

By the time Cox painted the watercolour of 'Ulverston Sands' he had developed a highly original technique. He had a free and expressive way of handling watercolour which he used in portraying atmospheric effects with masterly ease. In this picture the sky dominates the composition and the expressive and vigorous way in which it is painted makes us almost feel the effects of the weather. Blinding rain, blustering winds and passing showers were all evoked in Cox's work. Another work by Cox, 'The Challenge', is in the Victoria and Albert Museum. As in 'Ulverston Sands' the menacing sky which foretells rain

dominates the composition and the way in which he used free downward brush strokes admirably portrays the effects of the weather.

Cox helped to revitalise the Old Watercolour Society by regularly exhibiting there and he also exhibited at the Royal Academy at infrequent intervals from 1805 to 1844. He supplemented his income by teaching first at Dulwich and then in 1814 at a ladies' college in Hereford. Cox not only travelled extensively in England and Wales, but he also went to Belgium, Holland, Paris, Dieppe and Boulogne. The influences of both Turner and Constable are evident in Cox's work, particularly in his loose treatment of clouds and of skies. Cox's ideas about landscape were embodied in his work *A Treatise in Landscape Painting and Effect in Watercolours*, which was published in 1814. In 1829 he returned to London where he lived until 1841, when he moved to Harborne, Birmingham, where he died in 1859.

Peter de Wint (1784-1849)

Peter de Wint was born at Stone in Staffordshire, the son of a doctor of Dutch descent. Instead of following his father into the medical profession de Wint started an apprenticeship with the London engraver John Raphael Smith in 1802. However, he broke his agreement with Smith in 1806 and went to live with his fellow pupil William Hilton, whose sister he married in 1810. The Hiltons came from Lincoln and the city, the surrounding countryside and the similarly unspectacular agricultural lands of the Midlands became de Wint's favourite subject. In his early career he was also associated with Dr Monro and thus he became familiar with Girtin's work, which also influenced his style. Possibly the breadth of vision which he found in Girtin's work was something which he felt akin to because of his Dutch ancestry.

His ability to portray wide panoramas is shown in 'Clee Hills, Shropshire' (private collection, 15 by 20¾ inches, 380 by 530 mm). The Clee Hills are in the south-eastern part of Shropshire and de Wint would have known the scenery well through staying with the Honourable Robert Clive and his family at Oakley Park. He was greatly attracted to the Shropshire countryside and he painted many subjects of this area including 'Near Bridgnorth', now in the Usher Gallery, Lincoln, 'Titterstone Clee Hill Seen from the River Teme', in the Earl of Plymouth Collection, and 'Distant View of the Clee Hills from Oakley Park, Shropshire'. These watercolours, like the one in the private collection, are executed in a broad loose way which gives the feeling of striking emotional and atmospheric effect such as are normally associated with Girtin. Many of these Shropshire views

were exhibited at the Old Watercolour Society and helped to revitalise the institution, which had become dull and repetitive. De Wint exhibited regularly at the society from 1810 until the year of his death and at the Royal Academy infrequently between 1807 and 1828.

De Wint became drawing master to many families in different parts of Britain and this entailed a great deal of travelling. He became a very popular teacher. Although he visited Wales, the Lake District and Normandy in 1828, most of his inspiration came from the area around Lincoln and Shropshire. His work falls into two styles: the broad free style already described, and the more finished topographical style which was in vogue at the time, for example, his 'Gloucester Cathedral with Ruins of St Catherine's Church'. In his watercolours where he uses the looser technique de Wint showed that he was capable of an emotional and poetic response to landscape, a feature which we normally associate with Girtin. His work helped to improve the reputation of the Old Watercolour Society and thus the status of the medium of watercolour.

5. Watercolours of birds

Francis Barlow (1626-1704)

Francis Barlow made many sea voyages and kept a journal which he illustrated with drawings. Some of the liveliest of these were of birds and were etched by Francis Place. A good example is 'A Group of Birds in a Garden' (pen and brown ink and grey wash, British Museum, 8¾ by 12⅜ inches, 210 by 310 mm). Barlow used a wider range of colours than other watercolourists, including viridian green, lemon yellow, yellow ochre, rose madder, vermilion, brown and blue, although these colours were used by contemporary cartographers, but before that such a bright range of colours had been used only by the medieval illuminators of manuscripts. Other early watercolourists, including the topographers, hardly ever used bright colours, monochromatic tones of blue and grey being prevalent.

Charles Collins (died 1744)

Charles Collins continued the tradition of drawings of flowers and birds. A fine example of his work is 'A Rook' (Victoria and Albert Museum, 14¾ by 21¼ inches, 370 by 540 mm, signed and dated 1740).

George Edwards (1694-1773)

Another contemporary watercolourist whose life was devoted to the study of birds is George Edwards. His chief works are *A Natural History of Uncommon Birds and Animals...to which is added a general idea of drawing and paintings in watercolours*, published in four volumes between 1743 and 1751 (and which he dedicated to God), and *Gleanings of Natural History*, published in three volumes between 1758 and 1764. These books included nearly six hundred engravings of subjects never before drawn. They are all in gouache and the design is somewhat awkward because of the disparity in scale between the bird and its perch. A good example of his work is 'Bullfinches' (British Museum, 11⅝ by 9⅛ inches, 300 by 230 mm, watercolour and bodycolour on vellum).

John Gould (1804-81)

John Gould was probably the greatest of British bird artists and is sometimes called the 'British Audubon' (after the well known American bird painter). Gould first became interested in wild birds when he studied them in the gardens of Windsor Castle. In the 1830s he visited Europe, the Himalayas, India and Australasia with his wife Elizabeth and Edward Lear and whilst on these tours he produced drawings of great beauty. These

works were eventually published in eight volumes as *Birds of Australia* and included around three thousand previously unknown species of birds. However, Gould's masterpiece was *The Family of Hummingbirds,* painted in brilliantly rich colours with lavish use of gold. He also published *The Mammals of Australia* and *The Birds of Asia.*

Edward Lear (1812-88)

Another talented and famous artist who painted watercolours of birds is Edward Lear. Although he is also known for his nonsense verses and his watercolours of landscape, which he began to specialise in after the 1830s, his paintings of birds of the parrot family are among the finest of bird watercolours.

By 1832 he had completed drawings of the birds at the London Zoological Gardens and he included some of them in his book of coloured lithographs of parrots, *Illustrations of the Family of Psittacidae,* which was published in 1832. It was then that he met Lord Stanley, later thirteenth Earl of Derby, who kept a fine collection of birds and animals at Knowsley Park near Liverpool. Lear was asked to portray these. The watercolour of 'Blue Crowned Parakeet' shows his ability as a designer because, unlike his predecessor George Edwards, Lear has unified the bird with its perch and in so doing he has shown a subtle contrast of the differing textures of the feathers and bark as well as bringing out the anatomical features of the bird. The vivid colouring of the bird is brilliantly brought out by Lear and it shows how watercolour can be a supreme medium for bird illustration.

6. Portraits, figurative watercolours and book illustration

Although the development of the English watercolour in the eighteenth century was closely allied to the preference of artists to depict landscape as a subject, watercolour was also used for figure subjects, portraits, book illustrations and marine paintings as well.

John Collet (1725-80)

John Collett was born in London and was primarily a figure painter who liked to depict social scenes in a comic way rather in the manner of Hogarth and Rowlandson. Redgrave said that 'he plagiarised Hogarth, but missed his deep moral'. His popularity is reflected in the fact that between 1768 and 1774 at least thirty of his pictures were reproduced as mezzotint engravings, as were others two years after his death. He also painted a number of landscapes such as 'At the Inn Door' and 'On the River Bank', both of which may be seen in the British Museum. A more typical example of his work is 'An Asylum for The Deaf' (Victoria and Albert Museum), in which two deaf patients at a window are trying to hear a band, the sound of which, with other raucous noises of the street, cannot reach them. The exaggerated features of the people and their lively poses recall both Hogarth and Rowlandson. Collet used mostly ink with heavy shading and very little colour. This technique was suitable for reproduction as engravings.

Thomas Rowlandson (1756-1827)

Although chiefly regarded as a caricaturist who foreshadowed the work of both Gillray and Cruikshank, Rowlandson showed in all of his work, which included portraits, landscapes and figure subjects, that he was a superb draughtsman with a sure, expressive line. His work shows great creativity as well as an ability to interpret contemporary scenes with a lively wit.

He visited Wales with Henry Wigstead in 1797 and published a series of books, including *Microcosm of London* and *Three Tours of Dr Syntax*, which he worked on from 1812 onwards and was a satire on the artist's search for the picturesque. In 1784 he successfully exhibited 'Vauxhall Gardens' at the Royal Academy and he did a series of caricatures of the Westminster elections of that year.

He used a pencil for many of his brilliant sketches but everything done from them was done with a reed pen which he dipped in black ink or brown or bistre, sometimes with a mixture of vermilion. He used inks of different strengths but the ink was

watered so that it flowed from his pen with great fluency. His colour was limited and form was often created by thin tonal monochrome washes.

'Entrance to the Mall' is a brilliant study of landscape and costume as well as showing Rowlandson's talent for the comic — particularly the way in which he has exaggerated the couple at the centre of the picture. But above all it is the loose expressive penwork of Rowlandson which makes this work successful.

The success of his book illustration for the series *The Tour of Dr Syntax in Search of the Picturesque* was so great that the publisher, Ackermann, commissioned a further two series. Seventeen watercolours for these series are in the Victoria and Albert Museum and show Rowlandson's talents not only as a graphic illustrator but as an interpreter of the trends of his time with a refreshing liveliness.

John Downman (1750-1824)

John Downman had a long career as a painter of fashionable portraits of small size. They are very attractive in a pretty way which looks forward to the sentimental portraits of the Victorians. The rosy cheeks and white gowns are very pleasing to the eye, as are the blue and pink sashes, the mob caps and the great hats of straw. Interesting, too, is his record of the powdered 'sesquipedalian coiffure' which was in vogue from about 1770 to 1780. The pyramid of hair, piled up in rolls at the back, often had to last a long time. Downman usually preferred to paint his sitters in profile, making it easier to portray the hairstyle.

Downman drew on very thin paper in black chalk with a fine point, working over the shadows with a stump. Slight colouring was added to lips, cheeks and hair. This kind of work was called a 'stained' drawing. In some cases red chalk and occasionally a wash of sepia were used. Frequently the colour is laid on the back of the thin paper. This technique was developed by accident when one of Downman's children once dabbed some pink paint on to the back of a drawing of his wife. Downman was so pleased with the effect that he decided to incorporate it into his work.

An example of his work is his portrat of Mrs Siddons in the National Portrait Gallery, London (8 by 6¾ inches, 200 by 170 mm, black chalk and watercolour, signed and dated 1787).

Francis Wheatley (1747-1801)

Another figurative painter of the late eighteenth century was Francis Wheatley. In his obituary in the *Gentleman's Magazine*, 1801, Francis Wheatley's work is described as a 'pleasing display of rusticks in the variety of simplicity of rural avocation' but the writer complains that the figures are too often clad in 'French

fripperies'. Edward Edwards in his *Anecdotes of Painting* written in 1808 wrote that 'Wheatley's chief excellence was in rural subjects with figures, which when they represented females . . . were better suited to the fantastic taste of an Italian opera stage than to the streets of London'. This is clearly shown in the work called 'The Dismissal' (Victoria and Albert Museum, 13⅜ by 11¼ inches, 340 by 290 mm, signed and dated 1786), where the peasantry are idealised in gesture, hair and clothes. However, he produced some work which showed he could be a realist, for example 'Donnybrook Fair'. Although twenty years younger than Sandby, Wheatley worked very much in Sandby's manner. He drew with such fineness and precision that the drawings resemble engravings. He used big masses of tone and shadow and his colour range was limited to blues and greys.

Julius Caesar Ibbetson (1759-1817)

Julius Caesar Ibbetson was famed for his excellent drawings of animals, particularly cattle and pigs, but unfortunately he tended to include them in a way which made the picture look overloaded.

'The Market' (Laing Art Gallery, 8½ by 11½ inches, 216 by 292 mm) shows his ability to include animated figures which enliven a scene. They recall some of the work of Dayes, while other pictures, such as 'A Farmyard Scene', which includes a finely drawn group of pigs (Collection of Mr and Mrs Paul Mellon, 10⅝ by 15⅞ inches, 270 by 400 mm, signed and dated 1792), link him with artists like George Morland and James Ward.

Thomas Unwins (1782-1857)

The old tradition in figure subjects, portraits and book illustrations was continued by Thomas Unwins. He was frequently employed by Ackermann to do figure and costume drawings for publications. During his membership of the Watercolour Society from 1809 to 1818 he exhibited scenes from Shakespeare, Fielding and Sterne as well as small portraits and picturesque figure subjects and groups from the rural industries of his time such as hop and fruit pickers, plaiters, gleaners and lacemakers. After his resignation from the Watercolour Society he went on to paint scenes from Italian life in oil.

Thomas Stothard (1755-1834)

There were many illustrators of books and one of the most outstanding of them was Thomas Stothard. The son of the barber who shaved him was J. M. W. Turner and Stothard encouraged the boy to become an artist.

Thousands of readers owed to Stothard their conceptions of

favourite characters in such books as *Joseph Andrews, Tristram Shandy, Clarissa Harlowe, Sandford and Merton* and the *Pilgrim's Progress.* The British Museum has a good collection of his work.

Edward Francis Burney (1760-1848)

Edward Francis Burney was born at Worcester. He studied at the Royal Academy Schools, worked at portrait painting until 1803 and then devoted himself to book illustration. He published a *Collection of Theatrical Portraits* engraved from his drawings and he was also able to produce complicated figure subjects such as 'An Elegant Establishment for Young Ladies' and 'The Waltz'. The latter is in the Victoria and Albert Museum (18¾ by 27 inches, 480 by 690 mm). The figures appear almost to be caricatures. The newly introduced waltz was still regarded with suspicion and in this work it is treated in a humorous way.

William Blake (1757-1827)

The greatest book illustrator of the late eighteenth century was William Blake, whose work showed great technical skill as well as fine imaginative powers. William Blake was born in London and was apprenticed to James Basire, the engraver, from 1772 until 1779. Then he went to study in the Royal Academy Schools but his intense dislike of the Academy's President, Sir Joshua Reynolds, and of the medium of oil painting, led him to leave soon afterwards. Blake was an eccentric who came to loathe the art establishment and sought to escape from it by creating a private and mystical symbolism where 'Michelangelesque figures soar or struggle through a strangely flat cosmos in which every detail however decorative carried a spiritual significance' (Ian Bird, *The Genius of British Painting*).

Most of Blake's work was executed in watercolour. He exhibited his first watercolour at the Royal Academy in 1780 and during his lifetime he produced several sets of watercolours illustrating Milton, Dante and the Bible as well as his own poems, of which he wrote many. A powerful imagination infused all of his work and it helped him to evolve a highly original style and technique. His work is characterised by bold design, striking colour and unusual compositions, for which there are no precedents. Blake acknowledged the influences of Michelangelo and the medieval tombs of Westminster Abbey, but his talent was such that he was soon to absorb these influences and create something entirely new from them. His highly individual genius was revealed in his thirties when he produced a series of illuminated books, writing the text, producing the illustrations and printing the books himself. These included *Songs of*

Innocence (1789), *Songs of Experience* (1794) and *The Book of Urizen* (1794). Towards the end of his life, in the 1820s, Blake executed some exquisite watercolours illustrating scenes from Dante's *Divine Comedy*. These show Blake to be one of the greatest of the English watercolourists.

In about 1794 Blake produced one of his most powerful designs, known as 'The Ancient of Days, Daniel Chapter VII, 22'. It portrays Urizen creating the universe and Blake used it as a colour print frontispiece to his *Europe, A Prophecy*. The motif of the compasses is the symbol for the act of creation as described in Proverbs, chapter VIII, 27: 'When he prepared the heavens, I was there: when he set a compass upon the face of the depth.' The symbolic representation of the act also corresponds with Milton's description in *Paradise Lost,* Book VIII, 124-31: 'Then staid the fervid Wheeles, and in his hand He took the golden Compasses.' Blake also refers to the symbol of the compasses in his own writings. In his prophetic books of 1793-5 Blake invents his own mythology to illustrate his beliefs and to express his ideas on the creation. Urizen, the creator, is a character to be identified with the Old Testament's Jehovah, an evil oppressor who decreed law and reason so that imagination became stifled. The conflicts caused by this oppression are recounted in these books. There are several watercolour versions of 'The Ancient of Days', but the one in the Whitworth Art Gallery is probably the one with the richest colouring.

From about 1800 to 1806 Blake was 'painting small pictures from the Bible'. One of them, which was probably finished between 1805 and 1806, is Blake's imaginative interpretation of Jacob's dream as told in Genesis, chapter XXVIII, 11-13, 'And he lighted upon a certain place . . .' Blake first exhibited this drawing in the Royal Academy in 1808. The bold design is of an elegant spiral of steps representing the ladder of which Jacob dreamed set upon the earth. On the steps are a series of elegant, graceful, elongated figures clothed in long flowing robes, with stars on either side of some of them, and at their foot the sleeping figure of Jacob.

In the years immediately preceding his death Blake was engaged on several projects including the set of illustrations to Dante's *Divine Comedy*. According to John Linnell, Blake first started work on them when he was confined to bed with a scalded foot and he found him not inactive but 'making in the leaves of a great book (folio) the sublimest designs from his (not superior) Dante . . . He designed them (100 I think) during a fortnight's illness in bed.' 'The Simoniac Pope' is one of the most outstanding designs of the whole series and is executed in pen and watercolour. It illustrates Canto XIX and shows Virgil holding on to Dante protectively as they look down from the

mouth of a cave at the writhing figure of Pope Nicholas III. The naked Pope (1277-80) is undergoing the torture of being placed head down in a well of fire, the punishment of those accused of simony. As other simoniac Popes are expected in turn to fill the well, so Nicholas III will be pushed further downwards into the threatening underworld.

Much of the preliminary work which Blake did for his illustrations was done in watercolour. He was a painter-poet *par excellence*. His inventiveness and imagination are unique in the history of the English watercolour. The rich bold colours and striking linear drawings are most effective and show how watercolour can be used in an expressive way.

Walter Crane (1845-1915)

The many great and well known book illustrators of the nineteenth century included Walter Crane, Kate Greenaway, Arthur Rackham and Beatrix Potter. These artists all worked in watercolour.

Crane was influenced by the Pre-Raphaelites and his pictures are full of symbolism and purely decorative elements, qualities which are strongly associated with the Pre-Raphaelites. Crane's first published illustrations appeared in a series of sixpenny toy-books published between 1864 and 1869: *The Railroad Alphabet, The Farmyard ABC, Dame Trot and Her Comical Cat, The Song of Sixpence* and many others. In these books he was limited to three colours, red, blue and black. He included more colours in *The Fairy Ship* in 1869 and even more in the famous *Baby's Opera* of 1877. He worked closely with his printer, Evans, who was very careful to transpose the line and colour as accurately as possible into print. The decorative qualities which were achieved by superb graphic skill combined with a flair for colour are evident in many of his designs, of which 'Pan Pipes' in the British Museum is a typical example.

Kate Greenaway (1846-1901)

Ruskin wrote of Kate Greenaway's work: 'She ruled... in a ... land of flowers and gardens, of red-brick houses with dormer windows, peopled by toddling boys and little girls clad in long waisted gowns, muffs, pelisses and mob caps. In all her work there is an atmosphere of an earlier peace and simple piety.'

It was not until 1879, when she wrote and illustrated *Under the Window,* that Kate Greenaway achieved recognition. The book was an outstanding success both in Britain and elsewhere, with about one hundred thousand copies being printed. *Under the Window* was followed by *Mother Goose* in 1881, *The Language of Flowers* in 1882, *Marigold Garden* in 1885 and many others. She also published yearly almanacks from 1883 to 1897.

Arthur Rackham (1867-1939)

Book illustrations had always been reproduced by wood engravings until the invention of the three-colour photographic process. This new technique enabled watercolours to be reproduced accurately and rapidly by technical means which, unlike wood engraving, did not rely on the skill of the operator. One of the first artists to exploit the possibilities of this new technique was Arthur Rackham.

He began by doing black and white illustrations but then he was commissioned to make colour illustrations for *Rip Van Winkle* (1905), *Peter Pan* (1906) and *Ingoldsby Legends* (1907), but his fame rests on his illustrations to *A Midsummer Night's Dream* (1908) and Grimm's *Fairy Tales* (1909). In these volumes he created his own fairyland with elves, sprites, dwarfs and gnomes whom children adored. They inhabited a landscape of gnarled trees whose branches were inhabited by snakes, spiders, snails, mice and birds which seemed to be part of the knotted bark, just as the fairies peeping out were. His subjects were the product of a highly imaginative mind but he was also a talented watercolourist. He evolved his own technique. He usually washed his pen drawing with a tint of raw umber, leaving spaces where the pure colour was to go. He was always careful to make sure that the tones of the colour went from warm to cold so that the picture was unified in tone. Thus the overall impression of his work was of an off-white gold-tinted quality which has affinities with vellum and ivory.

Rackham did watercolours which were not intended as book illustrations and which show his talents as a landscape painter. This talent was used in his last work, the illustrations for Grahame's *The Wind in the Willows*, which was published after his death.

Beatrix Potter (1866-1943)

Beatrix Potter had a lonely childhood, which probably helped to foster a fertile imagination. She said: 'I do not remember a time when I did not try to invent pictures and make for myself a fairyland amongst the wild flowers, the animals, the fungi, mosses, woods and streams, all the thousand objects of the countryside.' But it was not until she was in her middle thirties that she published her first book, *The Tale of Peter Rabbit*. As a result of its success she left her parents and bought Hill Top Farm at Sawrey above Windermere, and during a productive period of eight years she produced all her best work.

Her father knew the painter Millais, who gave her advice about the technical aspects of painting. The family often went on long holidays to Scotland and the Lake District, where Beatrix could study at first hand 'the thousand objects of the country-

71

side'. Other sources of inspiration came from exhibits in the Natural History Museum, London, and from her own pets. The stimulus to write the books came from her continued friendship with her former governess, who left the Potter household to marry and have eight children. The first version of Peter Rabbit appeared in a letter from Beatrix to her governess.

Beatrix Potter's strong and determined character is reflected in her desire to ensure that all the watercolours were reproduced accurately by the publisher, Frederick Warne. Ironically the immense success of the books has led to their inferior reproduction as the original printing blocks have not been renewed, but her original work was characterised by strong, vibrant colour with precise details clearly outlined. For instance, the carrots and other vegetables in *The Tale of Peter Rabbit* were observed with great accuracy both in descriptive detail and in colour. Similarly each plant, blade of grass and stone in the world which the animals inhabit is reproduced with astonishing botanical precision, with an abundance of tiny detail closely observed and painstakingly recreated. Peter Rabbit, Tom Kitten, Jemima Puddleduck and the little mice in *The Tailor of Gloucester* (which some consider to be her most outstanding artistic work) wear charming frock-coats, frilly bonnets and skirts which are the product of a lively and fertile imagination and have fascinated generations of children and adults. The Tate Gallery has 22 of the original watercolour drawings for *The Tailor of Gloucester*, published in 1902.

In 1913 Beatrix Potter married a solicitor and, shunning admirers of her books, she devoted herself to sheep farming with the same determination which she had applied to her writing and painting, eventually becoming President elect of the Herdwick Sheepbreeders Association.

William Henry Hunt (1790-1864)

William Henry Hunt is an important figure in the history of the English watercolour as he was probably the inventor of a technique which was later adopted by artists such as Lewis, Birket Foster and the Pre-Raphaelites. However, his early work used the popular transparent washes which one normally associates with pure watercolour technique.

Hunt was born in London, the son of a tin-box maker. He entered the studio of John Varley in 1806 and Varley's work greatly influenced him in his formative years. About the same time Dr Thomas Monro gave him valuable financial support as well as encouragement. His earliest works were of topographical landscapes but because he had deformed legs he found it difficult to execute outdoor work and this changed his choice of subject matter. In the mid 1820s Hunt was commissioned by William

Spencer, sixth Duke of Devonshire, to make drawings of the state rooms at Chatsworth, Hardwick, Devonshire House and Chiswick, and by the Earl of Essex to carry out similar work at Cassiobury Park. This gave him the idea of placing rustic figures in interiors, although he had to adapt the luxurious settings he had been painting to more humble dwellings.

Between 1824 and 1838 he produced a number of rustic interiors, which included 'The Outhouse' (Fitzwilliam Museum, Cambridge), 'Plucking the Fowl' (British Museum) and 'The Maid and the Magpie' (1823, Cecil Higgins Art Gallery, Bedford). The rustic figures were members of his own family who modelled for him. Hunt's rustic scenes appealed to the sentiment of the early Victorians. They were mostly painted in transparent watercolour, although with 'The Outhouse' body-colour was used too, which gave the work an opaque effect.

In 1824 Hunt was elected an Associate of the Old Watercolour Society and two years later a Member, and many have seen this as a turning point in Hunt's work, for after this date Hunt changed his choice of subject matter. In 1827 he began to show studies of flowers, fruit and vegetables as well as pictures of sporting themes and studies of dead fowl. From 1830 he began to show birds' nest subjects such as 'A Bank of Primroses with Birds' Nest', which is in the Tate Gallery London.

This change in subject matter benefited him because he was able to work in the studio and did not need to move about very much. These subjects also allowed him to develop his talent for minute observation and the ability to paint with a microscopic, almost photographic intensity, such as we normally associate with the Pre-Raphaelites. For this work he invented a new technique in watercolour which is described in the biography of James Orrock and quoted by Martin Hardie in one of his books on watercolour painting in Britain: 'He would, for instance, roughly pencil out a group of flowers or grapes and thickly coat each one with Chinese white, which he would leave to dry. On this brilliant china-like ground he would put his colours, not in washes, but solid and sure, so as not to disturb the ground which he had prepared. By this process the utmost value for obtaining strength and brilliancy was secured for the colours were made to "bear out" and almost rival nature herself.'

His brilliant technique was particularly effective in portraying different textures and appearances such as the bloom on plums, wicker baskets and the birds' nests which became something of a hallmark of his work and earned him the nickname of 'Birds' Nest Hunt'. He was able to depict the varying tactile qualities of different objects as well as fruits, flowers, people and interiors with consummate ease. He was admired by and influenced many artists including the Pre-Raphaelite Brotherhood, who adopted

his technique of painting. He died in London in 1864.

Myles Birket Foster (1825-99)

A popular watercolourist of the Victorian era who adopted Hunt's technique was Myles Birket Foster. As with Hunt, much of Foster's work reflects the Victorian sentiment of the time. Often if a figure or two are included in his work they look posed. His best work consists of groups such as the charming 'Children Running Downhill', which is in the Bethnal Green Museum of Childhood, London. The action and movement portrayed here is lively and natural and shows Foster's ability to observe as well as to produce a fine composition. His technique, like Hunt's, was meticulous, had a high degree of finish and used bright colour. Most of his work was small although 'Children Running Downhill' is larger than usual, being 13 by 28 inches (330 by 710 mm). Walter Sickert wrote: 'Oh for one hour of Birket Foster, with his darling little girls playing at cat's cradle, or figuring on their little slates.' This comment reflects the sentiment which was apparent in Foster's work but Sickert wrote later: 'Birket Foster's children bear the imprint of truth in every lovely gesture.'

Birket Foster was born at North Shields and educated at Quaker schools at Tottenham and Hitchin. Foster became apprenticed to Peter Landell, one of the leading wood engravers of the day, who had himself been a pupil of the talented wood engraver Bewick. Foster cut blocks for *Punch*, the *Illustrated London News* and other magazines. Sometimes he was sent out into the country to produce topical scenes and through this he developed a love of the countryside. Book illustration reached its peak in nineteenth-century England, but by 1859 Foster had already found patrons for his watercolour work and so he gave up his wood engraving for books. In 1860 he was elected an Associate of the Old Watercolour Society and a full Member in 1862. From then until his death in 1899 he exhibited about four hundred drawings and these represented only a fraction of his output.

In 1852, 1853 and 1861 Birket Foster travelled on the continent of Europe, notably up the Rhine, and in 1868 he visited Venice and produced some lovely watercolours, now in the Victoria and Albert Museum, of its famous buildings such as Santa Maria della Salute and San Giorgio Maggiore. In 1863 he built a house at Witley near Godalming and many of his drawings portray Surrey scenes.

Birket Foster did his outdoor works on blocks which he could slip into his pocket or in tiny sketchbooks. His colour box was small and he used few colours. Like Hunt, he worked in colour over Chinese white. He first made a careful pencil drawing and

often covered parts of it with transparent colour. He then applied patches of Chinese white, over which he worked with stipple or hatched strokes of pure colour. Birket Foster's method of working was followed by Helen Allingham.

Foster belongs to the school of artists who are often referred to as the Victorian Picturesque. This is because he chose to represent the charming aspects of nature as well as including children and solitary figures which appealed to the sentiment of the Victorians. Three examples of the combination of these two elements are 'The Milkmaid', 'Bringing Home the Cattle' and 'Lane Scene at Hambledon'. His pictures were immensely popular in his lifetime.

The Pre-Raphaelite Brotherhood

The Pre-Raphaelite Brotherhood was formed in 1848 after talks between Holman Hunt and John Millais. They were joined by Dante Gabriel Rossetti and his brother William, Collinson, Woolner the sculptor and Stephens. They all shared a dislike of Raphael and the deadening effect his work had had on English art and in particular they loathed the sentimental work which was in vogue at the time. They sought to paint serious subjects, often with a literary basis. Their pictures were often full of symbolism and the iconography was freshly thought out. Hunt in particular was keen to go out of doors and paint what he saw, thus being truthful to nature. In this respect the Brethren were influenced by and followed on the English landscape tradition. Their work is characterised by bright colour and extreme detail and they followed William Henry Hunt, Lewis and Birket Foster in their method of working on to a white ground.

Many people consider Rossetti's work to be the most imaginative of the three leading members of the Brotherhood (the other two being Holman Hunt and Millais). His water-colour work is certainly the most outstanding.

Dante Gabriel Rossetti (1828-82)

More than any of the other members of the Pre-Raphaelite Brotherhood, Rossetti made his appeal by mental images and symbols rather than by realistic representation of contemporary or other scenes. However, he did use models, especially for portraying the various female characters which he included in his work. Like William Blake, whom he admired, Rossetti was a painter-poet who brought poetry into his paintings and pictorial power into his poems.

Rossetti was born in London, the son of Gabriel Rossetti, an Italian refugee who became professor of Italian at King's College, London. Young Rossetti was educated at King's College and studied drawing under Cotman from 1837 to 1842.

In 1845 he entered the Royal Academy Schools, but whilst there he was composing poems rather than submitting to the drudgery of drawing. As a painter he was strongly attracted to the work of Ford Madox Brown, whose powerful influence permeates the early work of the Pre-Raphaelite Brethren. However, Rossetti soon grew impatient of academic tasks such as painting jam jars and pickle jars and he left Ford Madox Brown's studio and the classes he attended at the Royal Academy in order to share a studio with Holman Hunt, and so he became one of the founder members of the Pre-Raphaelite Brethren.

In 1849 Rossetti and Hunt toured France and Holland. Rossetti's first completed work in watercolour is 'The Laboratory', finished in 1849, which illustrated Browning's poem of the same title, particularly the lines 'In this devil's smithy, which is the poison to poison her prithee'. It is in the Birmingham Museum and Art Gallery and has a naivety and directness which is lacking in the later, more sophisticated work.

In 1851 he was assisted by Burne-Jones and others in painting a series of frescoes at Oxford. In 'The Blessed Damozel' and other poems he showed the same mystical intensity as is evident in his paintings. From 1852 he lived at 16 Cheyne Walk, Chelsea, with his brother William, Swinburne and Meredith.

About 1850 Rossetti first met Elizabeth Siddal. She sat for him and also for Hunt and Millais and became a symbol as well as a model to the Pre-Raphaelites. She became Rossetti's wife in 1860, after a long engagement. She inspired a great deal of Rossetti's work: she was his Beatrice in the three paintings taken from Dante, with whom he closely identified, his Virgin in 'The Annunciation', his Francesca da Rimini and his Ophelia. Her sensuous face, her brooding heavy eyelids, her drooping lips and straight neck and her mass of luxuriant reddish gold hair appeared in 'The Blue Closet', in 'The Wedding of St George', in the ghostly 'How They Met Themselves', in 'The Rose Garden', in 'Regina Cordnum' and, after her death, in 'Beata Beatrix'. On 10th February 1862 she committed suicide under mysterious circumstances, soon after their child had been born dead. Her looks epitomised the type of beauty closely identified with the movement and today the term 'Pre-Raphaelite' is often used to describe that type of beauty.

Rossetti was not a natural craftsman either in oil or in watercolour. However, it is this uncertainty of technique which gave his pictures an inner intensity, as one can sense him grappling with the technique in order to make the image seem real. This quality is often lacking in the work of such artists as Millais who painted with superficial ease so that although their work may be technically brilliant it is often lacking in mystical intensity.

Rossetti was probably influenced by Flemish painters such as Memlinc and Van Eyck, particularly by their rich jewel-like colour and their obsession with interiors, and also by the work of medieval illuminators. These influences may well have led him to use flat and vivid touches of scarlet, green and purple. Furthermore, his subject matter was often inspired by Dante and medieval legends such as that of St George, and instead of applying the science of perspective to his work, which he probably knew only very shakily, he chose to include a great amount of detail crammed into an interior without any space. Thus the general effect was one of a rich, elaborate tapestry which linked him more with the fifteenth-century Italian International Gothic Style than with the early Renaissance work which the Pre-Raphaelite Brotherhood sought to emulate. 'The Blue Closet', 'The Tune of the Seven Towers', the Dante drawings and watercolours and 'The Wedding of St George' all belong to the medieval world of chivalry and romance and were far removed from the industrial turbulence of the Victorian times in which he lived. In this respect the paintings were pure escapism.

The qualities of craftsmanship, power of design, lyric quality and exquisite colour are admirably shown in two of his finest watercolours, 'Dante Drawing an Angel on the Anniversary of Beatrice's Death' and 'The Blue Closet'. The former brilliantly captures the moment when Dante is caught unaware by his visitors, drawing an angel. The lovely design and rich blue colouring of Dante's robe all show Rossetti to be highly inventive and imaginative. 'The Blue Closet' was painted in 1857 and William Morris, who commissioned it, wrote a haunting poem containing the lines:

'... they give us leave,
Once every year on Christmas Eve
To sing in the closet blue one song
And we should be so long, so long,
If we dared, in singing.'

The long flowing robes, medieval dress, languid poses and the way in which the maidens are plucking the musical instrument in the centre of the picture combine to give this picture a haunting romantic flavour and a dreamy sensuous quality which are characteristic of Rossetti's work. The rich scarlets and greens and the blue and white tiles in the background give this interior an exotic look. The minute technique and concentration on textures link Rossetti's work with that of John Lewis, such as 'The Harem', painted a year later than 'The Blue Closet'.

Rossetti's work very much influenced his disciples Burne-Jones and William Morris, who formed a kind of second Pre-Raphaelite Brotherhood in Oxford from 1858 onwards.

After the death of his wife, Elizabeth, in 1862 and his unsatisfactory relationship with Jane Morris in the 1870s, Rossetti returned to London and led a dissipated life. He began to drink heavily and take enormous doses of chloral. These factors, combined with his own personal unhappiness, led to a degeneracy in his art. His last works were often executed in oil and were of ladies he knew or had known, but they lacked the imaginative power and lyric quality of works such as 'The Blue Closet', 'The Tune of the Seven Towers' and 'Dante Drawing an Angel on the Anniversary of Beatrice's Death'. Rossetti died in 1882.

Sir Edward Burne-Jones (1833-98)

Although Burne-Jones was not a member of the original Pre-Raphaelite Brethren, he, his friend William Morris and Rossetti formed what amounted to a second Pre-Raphaelite Movement in Oxford. Burne-Jones attended King Edward's Grammar School in Birmingham and went up to Oxford in 1852 with the intention, like William Morris, of entering the church. Both were influenced by the atmosphere of symbolism and medievalism apparent in Oxford at that time and were inspired by the beautiful collection of medieval manuscripts in the Bodleian Library there. Burne-Jones became a fervent admirer of Rossetti and determined to become an artist. He went to London and for a time worked with William Morris at 17 Red Lion Square, keeping in close touch with Rossetti. In 1857 he returned to Oxford, joining Rossetti, Morris and others who were working on the fresco decorations in the Union building. He visited Italy in 1859 and again in 1862. He was elected an Associate of the Old Watercolour Society in 1864 and a Member in 1868. In 1870 he retired but he rejoined in 1886. In 1885 he was elected an Associate of the Royal Academy but resigned in 1893. By that time he had gained a high reputation as a decorative painter in oil and was also distinguished as a book illustrator (notably for his superb designs for the Kelmscott Press publications) and as a designer of stained glass and tapestries.

In 1861 and 1862 Burne-Jones had painted in watercolour the supremely powerful and striking 'Clara von Bork' and 'Sidonia von Bork' (Tate Gallery), 'Merlin and Nimue' (Victoria and Albert Museum), three pictures of 'Backgammon Players', originally known as 'Chess Players' (Birmingham Museum and Art Gallery), 'The Annunciation' and 'An Idyll' (Birmingham Museum and Art Gallery). All these paintings show the influence and inspiration of Rossetti, particularly in their poetic intensity and sense of mystery.

'Sidonia von Bork' is a very striking watercolour and the treatment of the dress with its bold pattern and dramatic shape is

quite arresting. The colour in this work is warm and mellow. The subject was taken from Wilhelm Meinhold's *Sidonia the Sorceress,* published in 1847 and translated into English in 1849. The story traces the career of a woman of noble Pomeranian family who in 1620 at the age of eighty was executed as a witch at Stettin. Sidonia was so beautiful that all who saw her fell in love with her, but she was also incurably vicious. She pursued a life of crime, eventually bewitching the entire ruling house of Pomerania to death or sterility. The combined themes of beauty, evil and magic, together with a wealth of descriptive detail, appealed strongly to the Pre-Raphaelite imagination and, indeed, Rossetti admired Sidonia too. Morris was to reprint the book at the Kelmscott Press in 1893. Burne-Jones painted her as a typical Pre-Raphaelite beauty, with thick bushy hair, deep broody eyes and sensuous mouth. The sense of evil is reflected in the pose as she half turns in a suspicious way so that one can almost feel her mind plotting the next murder.

These early works of Burne-Jones illustrate his saying 'I mean by a picture a beautiful, romantic dream of something that never was, never will be....in a land no one can define or remember, only desire, and the forms divinely beautiful.' Another famous saying of his was that as the society in which he lived became more materialistic the more angels he would paint.

Burne-Jones enjoyed popularity in his own lifetime although it was beginning to decline before his death. Today, as with the other Pre-Raphaelites, his work is being viewed with far greater interest. His experiments with the watercolour technique are most interesting and of such quality that he had sometimes to state to a patron that a work was not done in oil.

Sir John Everett Millais (1829-96)

Two other important members of the Pre-Raphaelite Brotherhood were John Millais and Holman Hunt, but they did little work in watercolour, mostly working in oil.

Of the few watercolours Millais produced, the most outstanding were the exquisite drawings executed as studies for many of his Pre-Raphaelite paintings, such as the head of Ophelia and the studies of the individual heads and poses for the oil painting of 'Lorenzo and Isabella'. The most lyrical are 'My Second Sermon' and 'The Eve of St Agnes', both of which are in the Victoria and Albert Museum and were painted in 1862.

William Holman Hunt (1827-1910)

Holman Hunt painted only about 39 watercolours altogether and his prime importance is as an oil painter. For Hunt the essence of the Pre-Raphaelite movement was to paint 'the glory of the earth in actual sunlight'. He went out of doors to achieve

this effect and he evolved a technique of painting with transparent and often dry colours on a brilliant white paper; the effect was dazzling. The rendering of sunlight upon meadows and hills can be clearly seen in one of his works in watercolour entitled 'Helston, Cornwall', which he did in 1860.

7. Marine watercolours

THE SEVENTEENTH AND EIGHTEENTH CENTURIES
Several of the best English watercolour painters specialised in painting the sea, shipping and coastal scenery. Until the middle of the seventeenth century the sea was depicted as an endless repetition of jagged waves which were stylised and looked lifeless. At that time the Dutchman Bakhuyzen was one of the first artists to attempt to represent the actual movement of the sea, the tossing of ships and the unrest of the sky. It is said he employed mariners to take him on trips so that he could study the sea at first hand. His influence and that of the Van de Veldes, father and son, can be traced through the later Dutch painters to the British school.

The **Van de Veldes** made their home in England in 1673. Samuel Pepys wrote in 1673: 'Whereas wee have thought fitt to allow the Salary of One hundred pounds p. Annm unto William Van de Velde the Elder for taking and making of Draughts of seafights, and the like Salary of One hundred pounds p. Annm unto William Van de Velde the Younger for putting the said Draughts into Colour for our particular use.' So their official position alone, apart from the merit of their work, would have given them considerable influence. The elder Van de Velde's love of meticulous detail set a high standard of technical accuracy and his son mastered the portrayal of the play of light over air and water. These two characteristics were taken up by many of the marine painters of the eighteenth century.

Another development which changed the public's attitude to the sea was that for the first time visiting the coast became popular. Places like Brighton and Bognor had become fashionable and all over the coast little resorts began to grow up. Artists realised that the growing vogue for the sea, like the fashion for continental travel, afforded opportunities to paint and sell pictures. Like the mountains, lakes and towns of continental Europe the sea appealed to the romantic spirit of the artist. Many landscape painters made excursions to the sea. Turner, Constable, Cotman, Cox, Prout, de Wint, Copley Fielding and others all produced memorable seascapes, but some artists chose to specialise in sea subjects.

Peter Monamy (c 1670-1749)
Among the early masters was Peter Monamy. His inspiration came from the Van de Veldes, as is apparent in his work 'Old East India Wharf'.

Samuel Scott (c 1702-72)
Samuel Scott, like Monamy, made his reputation by painting

marine subjects in oil. Although his watercolours are rather timidly handled, for example 'A Shipbuilder's Yard' in the Huntington Art Gallery, California, his work is important as it stands at the beginning of a tradition which concentrated on portraying ships in meticulous detail.

Charles Gore (1729-1807)

Charles Gore, according to Farington, took great pleasure in sailing, 'having a Yacht for that purpose, and in sketching vessels and sea views which he so much excelled'. Apart from making his own sketches he bought Van de Velde drawings and worked over them with a pen and slight colour washes. 'An Armed Cutter in a Storm' (British Museum, 7⅜ by 10⅜ inches, 187 by 264 mm, watercolour and some bodycolour) shows Gore to be a master at portraying the detail of the ship and also capable of capturing the atmosphere of the sky. He also made the sea look like a powerful force and no longer just a pattern. Girtin studied Gore's work and was impressed by it.

Nicholas Pocock (1741-1821)

Another painter of this period was Nicholas Pocock. He had experience of the sea as he was a mariner. He made many drawings while at sea but when forty years old he gave up sailing to concentrate on his oil and watercolour paintings of the sea. He was one of the original members of the Old Watercolour Society in 1805.

Pocock's colour is restrained and his work is close to the 'stained' drawings of the topographical school. He strove to show the exact details of a ship and so his pictures are important records of naval history. An example of his work is 'Eastbourne, Sussex' (British Museum, 12⅞ by 17¾ inches, 327 by 451 mm), which shows how he concentrated on the vessels rather than on the sea itself.

John Cleveley (1747-86) and Robert Cleveley (1747-1809)

John Cleveley began drawing ships and other naval subjects at an early age. He was taught by Paul Sandby. Having made a name for himself, he was chosen as a draughtsman to accompany Sir Joseph Banks on his voyage to the Orkneys and to Iceland. Three of the watercolours he made on the voyage are in the British Museum and Victoria and Albert Museum. His handling of watercolour was lively. His twin brother, Robert, also painted marine subjects, including 'A View of Billingsgate at High Water', which he exhibited at the Royal Academy in 1792. Another example of Robert's work is 'English Ships of War' in the Victoria and Albert Museum (9½ by 15¼ inches, 240 by 380 mm), which shows great elegance and charm.

John Webber (c 1750-93)

John Webber accompanied Captain Cook in 1776 as draughts-man on his third voyage round the world in the *Resolution,* being present at Cook's death. On his return in 1780 he was employed by the Admiralty in making finished drawings of the sketches he had made on the expedition. In 1808 Boydell published *Views in the South Seas,* engraved by Webber from the original drawings. He became a member of the Royal Academy in 1791.

He was a good draughtsman and a delicate colourist. Like J. R. Cozens, he did not apply his colour on the spot. In his 'Near Dolgelley' (Victoria and Albert Museum) the colours are carefully noted in pencil — 'greenish', 'purplish', 'reddish hue', 'purplish hue' — but when the drawing was finished the mountains appeared as a silver grey. Also like Cozens, he preferred a cool colour scheme of silvery blues.

William Anderson (1757-1837)

William Anderson was brought up among shipwrights. He exhibited river and sea views at the Royal Academy from 1787 to 1834, pictures which showed his expert nautical knowledge. An example of his work is 'Coast Scene' in the Victoria and Albert Museum (8½ by 11¾ inches, 220 by 300 mm, signed and dated 1795). It has a feeling of airiness and although Anderson was aware of the details of the ships they are not tightly delineated. In some of his work Anderson used a knife point to help him portray the tips of the waves.

Samuel Atkins (1787-1808)

Another marine artist was Samuel Atkins. Atkins's work is rare but of high quality, as may be seen from 'Man o' War at Anchor Being Rigged' (Mellon collection, 8 by 11½ inches, 200 by 290 mm, signed). The details of the ship as well as the tossing movement of the waves have been well recorded.

THE NINETEENTH CENTURY

All these artists helped to foster an interest in the sea and shipping in the eighteenth century and helped to inspire later masters such as Turner and Cox, who produced some of their finest works of the sea.

The vogue for visiting the coast and sea bathing continued to provide marine painters with subject matter and employment in the nineteenth century. Some of their work was used as illustrations in Heath's *Picturesque Annual* in 1832 and in the volume entitled *Coast Scenery.* Furthermore, many patrons such as the Crown wished to have accurate portraits painted of their ships. There were thus two kinds of nineteenth-century marine painting: the realistic portrayal of a ship at sea, with all the

details of its ropes and rigging depicted with meticulous accuracy, and the romantic view of the sea concentrating on the storms and waves and moody skies. Marine paintings were so popular that artists could successfully concentrate solely on this subject.

From the mid 1830s J. M. W. Turner became increasingly interested in painting seascapes, particularly ships in stormy seas. He was so determined to portray the scene accurately that it is said that he tied himself to the mast of a ship during a storm so that he could study the stormy sea at close quarters. His success in painting such scenes inspired many artists of the nineteenth century to specialise in portraying ships in a stormy sea rather than depicting the sea in a stylised way as some eighteenth-century marine artists had done.

Samuel Owen (c 1768-1857)

Samuel Owen was a typical example of a marine painter who followed the stylistic tradition of the Van de Veldes, which combined a talent to portray the details of ships accurately with an ability to portray the sea as an animated force.

Clarkson Stanfield (1793-1867)

Although more famous for his oil paintings, Clarkson Stanfield did many watercolours whilst touring France, Holland, Belgium and Italy in 1829 and 1839. He did work for Heath's *Picturesque Annual* in 1832-4 and in his volume entitled *Coast Scenery* (1847) he did views of Falmouth, Portsmouth, Plymouth, Rye, Hastings and Dover. Work which looks less finished, such as 'The Dogana, Venice', shows his ability to portray atmosphere as well as his talents as a designer and a colourist.

George Chambers (1803-40)

Sidney Cooper said of George Chambers: 'Had he lived I feel convinced that he would have become one of the greatest marine painters of his time ... His painting of rough water was truly excellent and to all water he gave a liquid transparency that I have never seen equalled.' This quality may be seen in his work 'A Windy Day' in the Victoria and Albert Museum. He went away to sea at an early age and cruel jokes were made about his small stature, but once his talents as an artist were realised he gained respect from his colleagues. He gradually gained commissions for ship portraits and in 1830 the King sent for him at Windsor Castle. He was so terrified at the interview that when he was offered accommodation at the castle he said that he thought he would be more comfortable at the Red Cow! Nevertheless he was still commissioned to do four oil paintings, which are still in the royal collections.

In 1835 he was elected a member of the Old Watercolour Society and he exhibited about 41 drawings there in the last years of his life. These either depict ships or boats or are studies of waves and water with the coastal scenery of the Thames estuary. 'A Windy Day' belongs to this group and shows Chambers's talent for lively drawing and his ability to depict luminous clear colour.

Edward Duncan (1803-82)

Edward Duncan was less inspired than Chambers and he did animal paintings as well as marine pictures. His work was very popular with the Victorians because he could not only depict a scene in a meticulous, almost photographic way but also instil sentimentality into it. He was not interested in the realistic depiction of a stormy sea but instead he concentrated on the beach in the foreground. In 'Isle of Wight, The Channel Fleet Coming Out of Portsmouth' the far-off sea and ships are incidental, but the group of shrimpers, treated in a sentimental way, dominate the scene. Although every detail is painted with precision the sentiment is empty and lacking any real meaning, but it nonetheless appealed to the Victorians.

Charles Bentley (1805/6-54)

Charles Bentley made a close study of the work of Richard Bonington, whose influence may be clearly seen in many of Bentley's pictures. His subjects were generally of coast and river scenes. Sunset and evening, storm and calm all featured in his work. He sketched around most of the British and Irish coastlines as well as in Normandy and the Channel Islands. He visited Rouen and Le Havre with Callow in 1836 and he went to Paris with him in 1840 and 1841. An example of his work is 'Fishing Boats', which shows how he was able to portray the storminess of the sea with the rolling waves and fleeting sky.

George Balmer (c 1806-46)

George Balmer's best work was of marine subjects but he also exhibited rural and architectural scenes. In 1836 he began a publication called *The Ports, Harbours, Watering Places and Coast Scenery of Great Britain* which contained engravings of some of his best drawings but the work was never finished. 'Tynemouth Castle' is a typical example of his work and shows him to be a romantic painter as he has concentrated on a ship in a stormy sea, a subject which links him both with Bentley and with Turner.

Edward William Cooke (1811-80)

Before Cooke was nine he drew illustrations of plants for

Loudon's *Encyclopaedia of Gardening* and subsequently he made drawings and etchings for *The Botanical Cabinet.* Then he began to concentrate on accurately depicting every aspect of a ship, including the ropes, sails and rigging. He did these drawings in sketchbooks made up of Panny's patent metallic paper, which had a smooth shiny surface. These drawings were small in scale but the details and accuracy were astonishing and show Cooke to be an able draughtsman. In 1825 he was employed to make sketches of ship's gear for Clarkson Stanfield. He also exhibited oil paintings of sea and river scenes at the Royal Academy.

John Absolon (1815-95)

Absolon painted not only marine scenes but also landscapes and figure subjects. He used both oil and watercolour and he made numerous drawings for book illustrations. In 1838 he became a member of the New Watercolour Society. 'Coast Scene', which he did in 1860, shows how he has achieved a sparkling atmosphere by depicting sunshine and shadows by means of a fluid direct technique and a daring use of black. The picture is reminiscent of both Manet and Boudin and shows Absolon to be a superb painter.

Sir Oswald Walter Brierly (1817-94)

Brierly is chiefly remembered for being the marine painter to Queen Victoria and there are examples of his work in most of the large collections.

John Mogford (1821-85)

Mogford specialised in painting seascapes and rocky coasts. 'Coasts of Cornwall' is a typical example of his work. The rocky coast is depicted with photographic accuracy and contrasts with the seagulls and the mistiness behind, lending it a certain atmosphere and charm.

Henry Moore (1831-95)

Moore was influenced stylistically by the Pre-Raphaelites, as is clearly seen in his early minute style. He was one of the first to concentrate on depicting the vastness of the sea. He made innumerable studies of waves and boats in movement and these show him to have been a keen observer. His early photographic style later gave way to a looser, more expressive style associated more with the Impressionists. 'A Squally Day' is a good example of his work. It shows how the sea is the dominant feature of the picture and is done in his later, looser style. The colours used in his early work were mainly cold blues and greens, but in his later works he used deeper blues and greens.

Charles Edward Holloway (1838-97)

Until 1866 Holloway was associated with William Morris in the production of stained glass, but then he devoted himself to painting. His best work was of the Suffolk and Essex coasts. 'On the East Coast' and 'A Breezy Day' show him to have been a good artist with keen observation and a fine colour sense, but he did not experience popular success. His colours tended to be subtle and ranged from grey green to bluey greens. These cool colours perhaps show something of the influence of Whistler.

Thomas Bush Hardy (1842-97)

Thomas Bush Hardy was a very popular artist who specialised in depicting stormy seas with vivid colours. 'Hay Barge', which he did in 1878, is a good example. It depicts a barge being tossed about in a stormy sea and the moody sky above heightens the effect. His work, however, shows his lack of skill as a draughtsman.

Colin Hunter (1841-1904)

Colin Hunter specialised in depicting stormy seas off the western Highlands of Scotland. His work shows him to be a good colourist as well as a keen observer of the movement of a stormy sea.

William Frederick Mayor (1866-1916)

William Mayor's best work is of beach scenes, 'The Bathing Tent' being an excellent example. He was able to depict with the minimum of detail the atmosphere of the beach, using just a few bold strokes and flashes of brilliant colour to convey the scene before him. His pictures are among the liveliest watercolours of beach scenes and are thoroughly modern in feeling.

Nelson Dawson (1859-1941)

Nelson Dawson concentrated on painting scenes from the east coast of England, including Whitby, Yarmouth and Suffolk. His drawings were simple, direct and full of atmosphere. He could convey a good impression of a breezy day for example, as well as accurately depicting a ship, for he was also an excellent draughtsman.

8. Watercolour societies

The Society of Artists of Great Britain had held exhibitions of oil paintings and watercolours from 1760 to 1791 and the Free Society of Artists also held similar exhibitions from 1760 to 1783, but both societies closed down owing to lack of public support and possibly because they were unable to compete with the attractions of the Royal Academy, which was founded in 1768. Painters depended upon commissions from publishers of topographical engravings, upon private patrons and upon teaching pupils. After 1791 the Royal Academy exhibition, held from 1780 at Somerset House, was the only place where a watercolour artist could display his work publicly. At the Academy, however, watercolours were still regarded merely as tinted or stained drawings and they were hung badly, in poorly lit rooms, where they were not seen to advantage and where they were often surrounded by 'garish pictures in oils'.

When the Academy was founded in 1768, it was stated that the members were to be painters, sculptors or architects, and painters at that time meant painters in oil as in 1768 no watercolour drawing was ever described as a painting. Thus a person who painted only in watercolour was barred from becoming a member of the Royal Academy.

In 1804 the Old Watercolour Society was founded and the immediate success of the society's first exhibitions eventually led to the Royal Academy allowing watercolours to be shown at its exhibitions. However, the attitude of the Academy to watercolour painting is revealed in the fact that they did not elect a watercolour painter as an Associate of the Academy until 1943.

The opening exhibition of the Old Watercolour Society was a great success and during the six weeks it was on over twelve thousand people attended. The society's purpose was set out in a note at the beginning of the catalogue: 'The utility of an exhibition in forwarding the fine arts arises not only from the advantage of public criticisms, but also from the opportunity it gives to the artist of comparing his own works with those of his contemporaries in the same walk.'

In 1807 the New Society of Painters in Miniature and Watercolour was founded. This association accepted portraits too and became a rival to the older society while at the same time providing other watercolourists with the opportunity of exhibiting their work. The New English Art Club, originally called the Society of Anglo-French Painters, was founded in 1886 and gave watercolourists the opportunity to display all kinds of subject matter.

The foundation of watercolour societies was partly a recognition of watercolour painting as an art in its own right. Before,

watercolours had merely been regarded as drawings or used as preliminary sketches for works in oil. Also, the talents of many watercolour artists deserved public recognition. Artists of the calibre of Girtin and Turner did much to bring about this change and to make the Royal Academy accept watercolours for their exhibitions. However, the Academy's treatment of watercolour and watercolour artists made the foundation of these societies necessary. The societies were important because they provided artists with a place where they could exhibit their work and sell it, and it also gave them an opportunity to view the work of other artists. The foundation of watercolour societies in the nineteenth century reflected the growing interest in watercolour as well as the superb achievements which many artists had made in the medium.

9. Twentieth-century watercolours

In the twentieth century many artists have questioned the previously accepted view of what a painting is. Most people had considered that a painting should portray readily recognisable figures, objects or views which looked three-dimensional and conformed to the scientific rules of perspective. Successive art movements in the twentieth century, including Post-Impressionism, the Fauves, Cubism, Futurism and Vorticism, challenged this view of what a painting should consist of, often by treating objects, figures, portraits and views so that they appeared as a series of abstract shapes and colours rather than as a realistic representation. Watercolour was used by artists who were involved in these various art movements but it reflected rather than set the trends. Mostly oil and the new acrylic paints were used and in some of the art movements such as Cubism new techniques such as collage were developed.

Today watercolour has not emerged as a preferred medium by artists. Few artists use it exclusively, possibly because of the fragility of the medium and the difficulty of exhibiting water-colours permanently in public galleries. Nevertheless a wide variety of subjects with an equally wide interpretation has been depicted by twentieth-century English watercolourists. Land-scape, fantasies, nudes, still life, figurative works, costume designs, book illustrations, including botanical drawings, studies for oil paintings, architectural drawings and abstract paintings are all subjects which have been painted in watercolour in the twentieth century.

Artists connected with the Camden Town group — Ginner, Gilman, Bevan and Ratcliffe — all painted in watercolour, choosing urban life as their subject matter.

One notable art movement which emerged between 1913 and 1915 in England was a group known as the Vorticists, who evolved an abstract style which combined bright vibrant colour with striking shapes, fusing some of the ideas employed by the Cubists and the Futurists. The group included Wyndham Lewis, William Roberts, David Bomberg, Laurence Atkinson and Edward Wadsworth.

The Omega workshops organised by Roger Fry fostered a great deal of work in the applied decorative arts such as in designs for curtain materials, some of which have been revived by Laura Ashley in her Bloomsbury Collection. Some of the work for these designs was done in watercolour. Vanessa Bell did some fine work. These designs use unusual and dramatic combinations of colour. Duncan Grant and Edward Wolfe were associated with Fry, and Wolfe used a highly keyed watercolour palette.

In the 1930s and 1940s two of England's finest artists, Graham Sutherland and John Piper, started to use watercolour in topographical landscapes, such as Piper's 'All Saints' Chapel, Bath' (1942). Both these artists evolved individual styles employing inventive combinations of techniques veined with romanticism.

When the Second World War broke out in 1939 the Pilgrim Trust commissioned a large series of drawings and watercolours under the title 'Recording Britain'. The purpose of the scheme was for artists to record areas and buildings of Britain which might be destroyed as a result of the war. The artists chosen included John Piper, Kenneth Rowntree, Elliott Seabrooke, Claude Rogers, Ruskin Spear and Walter Spaye Bayes. These works belong to the Victoria and Albert Museum although some have been lent to other institutions. Paul Nash recorded the war in the air and Henry Moore concentrated on portraying the forms of the sleeping populace who huddled in underground air-raid shelters while above ground London was being bombed.

Today the various traditions which have been fostered by watercolour continue. Artists still go out of doors and record the fleeting changes of the atmosphere and sky. Some still use watercolour as a wash or stain over a precise architectural drawing, as the topographers did, whilst others such as Alan Reynolds in his 'Teazles' echo a tradition of botanical illustration which stretches back to the sixteenth-century painter Jacques le Moyne de Morgues. Yet others, like Patrick Procktor, have used watercolour to convey the freshness and vibrancy of a vase of flowers in a highly inventive way. All the familiar subjects are found, including in addition abstract paintings such as Patrick Heron's 'Pink and Black'. All these artists have recognised the delicacy of watercolour as a medium and its potential for depicting natural colour. Certainly it is the freshness and immediacy of the watercolour technique, the feeling that the artist has just recorded a scene and then put his brush down, that holds its universal appeal.

10. Collecting watercolours

It is advisable to choose a theme for a collection of watercolours, concentrating on pictures of a particular period or by an artist you like. For instance, you may decide to collect Victorian watercolours, watercolours of a particular town or county, or perhaps watercolours of still life.

Buying a watercolour

Watercolours may be bought from auctions, reputable shops and art galleries. Auctions are usually the cheapest source but it is sometimes difficult to make the necessary close examination of a watercolour before purchase. In shops and art galleries there is usually more time and opportunity to examine the work closely and often experts are at hand to advise on your purchase. Unlike prints, watercolours have become very expensive and forming a collection of quality watercolours will require a considerable financial outlay.

When examining a watercolour it is vital to notice whether or not the work has been exposed to the light with the result that the colour has faded. Also it is important to notice whether or not there are any stains, tears, repairs or repainting which will alter the value and the appearance of the work. It is advisable to look at the mount and the frame to see if the work has been glued to the mount or cut down to fit the frame; in both cases the damage done will considerably reduce the value. Glue in particular harms the work, sometimes irreparably.

The large auction houses like Sothebys, Christies and Phillips all deal in watercolours, publish catalogues of forthcoming sales and have experts who will advise you about a sale or purchase or who will value a watercolour which you may wish to sell. Museums and art galleries will not value a work although they can usually give information about it.

Sotheby, Parke, Bernet and Company, 34/35 New Bond Street, London W1A 2AA. Telephone: 01-493 8080.
Christie, Manson and Woods Limited, 8 King Street, St James's, London SW1Y 6QT. Telephone: 01-839 9060.
Phillips, Son and Neale, 7 Blenheim Street, New Bond Street, London W1Y 0AS. Telephone 01-629 6002.
Abbot and Holder, 73 Castelnau, Barnes, London SW13. Telephone: 01-748 2416.

Cleaning and storage

Cleaning a watercolour is best left to experts. The British Museum and the Victoria and Albert Museum in London will advise but restoration work is a highly skilled and time-

consuming job and therefore very expensive.

Prolonged exposure to light leads to deterioration of a watercolour so if one wants to hang the work it should first be put in a suitable mount and frame and then hung where there is no direct light. This is why one rarely sees watercolours on permanent display in museums and art galleries. Most of the time public collections of watercolours are kept in special mounts with acid-free tissue over them and then put into special boxes called solander boxes. These are labelled and stored on shelves in a dark room which is kept at a constant temperature and also has a humidifier in it.

11. Further reading

Hardie, Martin. *Water-Colour Painting in Britain* (three volumes). London, 1966-8. The fullest and most recent survey of most of the ground covered in this book. It contains a bibliography of general works and monographs on individual artists and the present author is deeply indebted to it.

Reynolds, Graham. *A Concise History of Watercolours*. Thames and Hudson, 1971. A good introduction to the subject which also covers the development of the European watercolour.

Catalogues of exhibitions of English watercolours and standard monographs on individual artists will also prove invaluable.

12. Places to visit

The museums and galleries listed here all have excellent collections of English watercolours. Before visiting any of these public collections it is necessary to write well in advance stating which watercolours you wish to see so that you can be told when it will be possible to view them.

Ashmolean Museum of Art and Archaeology, Beaumont Street, Oxford OX1 2PH. Telephone: Oxford (0865) 278000.

Birmingham Museum and Art Gallery, Chamberlain Square, Birmingham B3 3DH. Telephone: 021-235 2834.

British Museum, Great Russell Street, London WC1B 3DG. Telephone: 01-636 1555.

Buckinghamshire County Museum, Church Street, Aylesbury, Buckinghamshire HP20 2QP. Telephone: Aylesbury (0296) 82158 or 88849. (Watercolours primarily of topographical interest; others on loan under the 'Recording Britain' scheme.)

Castle Museum, Norwich, Norfolk NR1 3JU. Telephone: Norwich (0603) 611277 extension 279. (A fine collection of the Norwich School of painters.)

Cecil Higgins Art Gallery and Museum, Castle Close, Bedford MK40 3NY. Telephone: Bedford (0234) 211222.

Courtauld Institute Galleries, Woburn Square, London WC1H 0AA. Telephone: 01-580 1015 or 01-636 2095.

Fitzwilliam Museum, Trumpington Street, Cambridge CB2 1RB. Telephone: Cambridge (0223) 332900.

National Maritime Museum, Romney Road, Greenwich, London SE10 9NF. Telephone: 01-858 4422. (Marine watercolours.)

Tate Gallery, Millbank, London SW1P 4RG. Telephone: 01-821 1313. The Clore Gallery within the Tate has the finest and largest collection of Turner's work.

Victoria and Albert Museum, Cromwell Road, South Kensington, London SW7 2RL. Telephone: 01-589 6371.

Whitworth Art Gallery, University of Manchester, Oxford Road, Manchester M15 6ER. Telephone: 061-273 4865.

Index

INDEX